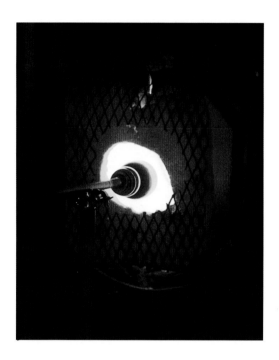

to my mother, Eleanor Balzer, who encouraged me to write, and to

my father, Edward Balzer, who encouraged me to dream.

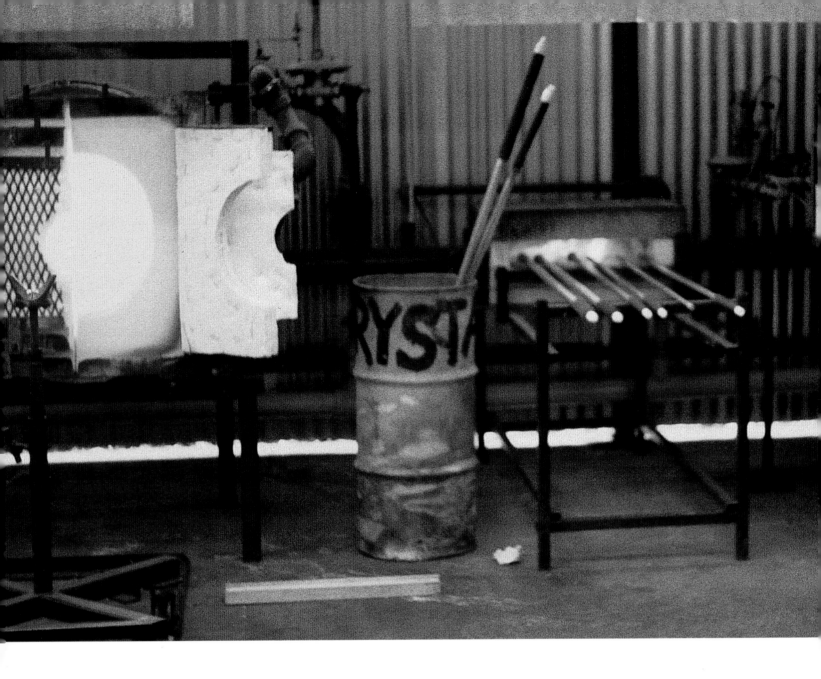

OUT OF

BY BONNIE J. MILLER

PORTRAITS BY ROBERT LYONS

THE FIRE

CONTEMPORARY GLASS ARTISTS AND THEIR WORK

CHRONICLE BOOKS · SAN FRANCISCO

Designed by Scott Hudson, Marquand Books, Inc.

Printed in Hong Kong

Pp. 2–3, Benjamin Moore's studio, Seattle

Miller, Bonnie J.

 Out of the fire: contemporary glass artists and their work/by Bonnie J. Miller.

 p. cm.

ISBN 0-87701-893-6 (pb).—ISBN 0-8118-0054-7

 1. Glass art—Northwestern States—History—20th century.

I. Title.

NK5109.M5 1991

730'.0979—dc20 91-8077

 CIP

Photo Credits for Art Work

Bill Bachuber, 25; Bob Bahner, 105, 106; Eduardo Calderon 33, 39 (bottom); Tom Collicott, back cover (top left), 71–73; Linn Hamrick, back cover (background), 22, 23, 45, 46; Rob Hoffman, 48 (bottom); Russell Johnson, 82, 83 (top); Kevin La Tona, 92, 93; Walter Lieberman, 58 (bottom), 59; John Littleton, 39 (top); Richard Marquis, 68, 69; Marquis Budget Photo, 115; Douglas Schaible, 35, 36, 48 (top), 49; Mel Schockner, 38; Roger Schreiber, back cover (top right), 26, 31, 32, 55, 56, 61–66, 85–87, 95–99, 116, 117; Michael Seidl, front cover, back cover (bottom right), 21, 89, 90, 101–103, 109; Michael Van Horn, 58 (top); Rob Vinnedge, back cover (bottom left), 28, 29, 41–43, 51–53, 75–80, 83 (bottom), 108, 111–113.

Distributed in Canada by Raincoast Books,
112 East Third Avenue, Vancouver, B.C. V5T 1C8

10 9 8 7 6 5 4 3 2 1

Chronicle Books
275 Fifth St.
San Francisco, CA 94103

CONTENTS

PREFACE

I vividly recall the moment I became entranced by glass. It was the spring of 1981, and I stood in a San Francisco gallery. Before me was the most delicate arrangement of thinly blown vessels I had ever seen. The softly rippled forms, in a tender, shell pink, seemed to glow with their own light. The grouping was entitled *Seaform*, and was by an artist of whom I had never heard, Dale Chihuly. I wanted it for my own, but the price of three hundred dollars, for an art form I knew nothing about, and the piece's fragility, which would have to withstand a household of romping dogs and curious toddlers, stopped me. I did not realize then that, had I brought the vessels back to Washington, I might be returning them to their place of origin.

It is easy to regret leaving the *Seaform* piece behind: Chihuly's work now sells for much more than that amount. Yet that encounter engendered an interest in the glass arts that has enriched my life for over a decade—from collecting, to blowing, to writing about the artists who use glass as their medium.

During the 1980s, I have seen glass art grow far beyond blown work based on the vessel. Exhibitions of contemporary glass encompass work that ranges from the most traditional, Italianate goblets to abstract sculpture where glass may be only a focal point within forms of wood, steel, or concrete. Such diversity can cause difficulties for collectors and galleries and for writers, like myself, who have specialized in the "glass" arts—where does one draw boundaries? At the same time, the explosion in technique and form is part of what keeps me fascinated with the work and with the artists.

When I first started writing about glass, I most wanted to know *how* the work was done. Over the years my interest has shifted from how to *why*? What matters most to the artist, how is that expressed, and where lies the satisfaction? The mystery in the alchemy of the glass and the passion it inspires in those who love the material only increase my curiosity about the people who are willing to work with such a difficult medium. The connection between the artists and their work has become more interesting to me than the art alone. I hope this book conveys something of that connection.

The Northwest is truly a mecca for glass artists of all approaches and abilities, and choosing among them was not easy. I have tried to show the spectrum of glass work available here—from blown work to sculpture, pure glass to mixed media, established artist to the just emerging—so that the reader could taste the breadth of choice within the field. With one exception. I did not include stained glass or architectural forms; they seem to need a book of their own. This book is intended to capture a moment in time, marking the journey of the glass movement in Washington and Oregon, and celebrating where it has arrived. But it is only a snapshot. The journey continues.

ACKNOWLEDGMENTS

This book would not have been possible without the help of many people. For contributing their oral histories, I would like to thank the following: Rob Adamson, Steve Beasley, Eric Brakken, Russell Day, Tom Diamond, Anne Gould Hauberg, David Keyes, Boyce Lundstrom, Johanna Nitzke, Alice Rooney, and Dan Schwoerer, as well as the thirty artists included in this book.

Thanks must also go to those who encouraged me and gave me help with the writing: Deanna Dally and Claudia Finseth for the hours spent listening and editing, Carole Parkhurst for reading and commenting, Megann Anderson for help with research, Karen Chambers and Megan Benton for advice, and, of course, my editors at Chronicle, Judith Dunham and Nion McEvoy.

Lastly, a special thanks to Fritz Dreisbach, who willingly gave me the benefit of his wonderful memory of the national and Northwest glass movements, and who took time to check my facts for accuracy; to Kate Elliott, who provided the historical photographs from the Pilchuck Glass School's files as well as historical information, and to my family, Ed, Lila, and Zach, who gave me love and support in every way throughout.

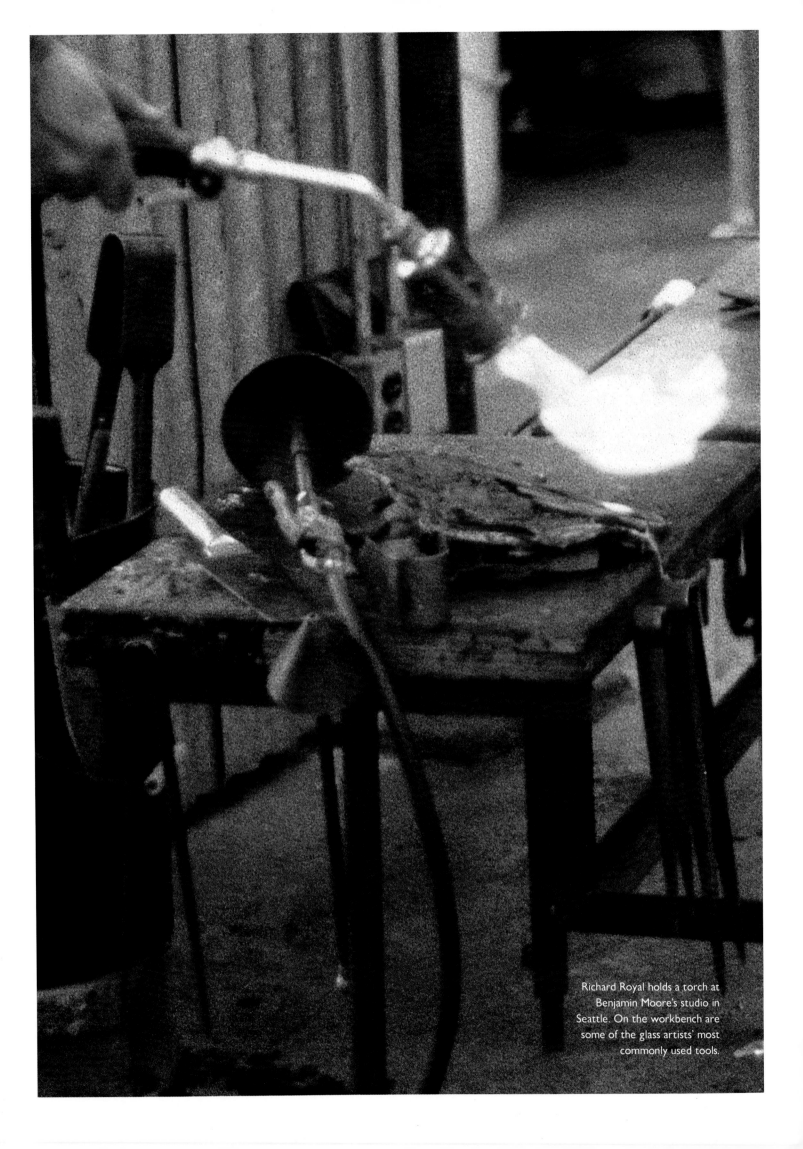

Richard Royal holds a torch at Benjamin Moore's studio in Seattle. On the workbench are some of the glass artists' most commonly used tools.

INTRODUCTION

On a snowy night in February 1990, a volunteer group of the Puget Sound glass community was scrambling. The international Glass Arts Society would hold its twentieth annual conference in Seattle the end of March. As hosts for the conference, the Northwest artists wanted it to be special, for it also celebrated Seattle's twenty years of evolution into a world-renowned center for the glass arts. To illustrate that growth, someone suggested providing a list of local studios and artists, another a map showing their locations. Although the artists knew the community had been increasing, even they were surprised to find, when everything was tallied, that there were more than three hundred people working in glass in the Northwest, over thirty individual hot shops, and more than fifty individual studios stretching from Portland, Oregon, to Bellingham, Washington.

Nowhere else in the United States is there such a concentration of glass artists. The influence of this community was underscored by Susanne Frantz, 1990 president of the Glass Arts Society and curator of twentieth century glass at the Corning Museum in Corning, New York, who stated in her introduction to the conference that "Seattle has developed into the most important center of contemporary glassmaking in the United States."

The beginnings of the Northwest as a center for glass are rooted in the "studio movement," which started in the spring of 1962, when Harvey Littleton, professor of ceramics at the University of Wisconsin in Madison, and Dominick Labino, vice-president and director of research at Johns-Manville Fiber Glass Corporation, devised a small glass melting furnace. A furnace small enough to be used in an individual artist's studio was innovative because it enabled artists to work with hot glass outside a factory setting, which until then had been nearly an impossibility.* Littleton and Labino gave two workshops that spring at the Toledo Museum of Art in Ohio, and the studio movement was launched. Its development in the Northwest did not begin until eight years later. When it did, a synchronicity of people, events, and elements unique to the area provided an ideal situation for this "new" art to thrive.

The ingredients that enabled a glass community to grow in the Northwest in the 1970s formed the warp and weft for the expansion of the glass arts here in the 1980s. Public programs sponsored by state colleges and local arts commissions, private patronage, visionary artists, grass-roots glass entrepreneurs, and the environment of the Northwest itself all wove together like threads on a loom. These elements did not exist simultaneously, but threaded side-by-side and end-to-end, overlaying and embroidering each other, they formed the rich tapestry that is Northwest glass today.

*Thomas Buechner, in the Foreword to Contemporary Glass: A World Survey from the Corning Museum of Glass by Susanne K. Frantz (Harry N. Abrams, New York, 1989), credits Parisian Jean Sala with having a small furnace for melting glass in his garage in the 1950s. I recommend Frantz's book for anyone who would like a broader understanding of the studio glass movement in the United States and Europe.

The five years from 1968 through 1972 were the seminal period for Northwest glass. Prior to the late 1960s, some glass companies existed and a few Northwest artists used glass sculpturally and in architectural commissions, but glass as an art material was relatively unknown. One of the few artists working in glass was Russell Day, now retired from the art department at Everett Community College in Everett, Washington. In 1956, at the University of Washington in Seattle, Day presented his master's thesis on modulating light in glass. The thesis committee found his show so intriguing that they prevailed upon the school of art to present it in the university's Henry Art Gallery. Day also met Harvey Littleton and attended one of Littleton's summer workshops at Madison in 1964. Later that year he recommended to Michael Whitley, an Everett student, and Dale Chihuly, a University of Washington graduate, that they apply to Littleton's program. Both completed it and eventually returned to Washington to start glass programs of their own.

Whitley returned first and, in 1968, set up glassblowing classes at Highline Community College in Des Moines, Washington, then moved on to establish a program at Central Washington University in Ellensburg, which he ran until his death in the early 1970s. Other Northwest colleges introduced glass almost simultaneously. In 1969, Tacoma ceramicist David Keyes, who had been at one of the Toledo workshops, was hired to start a glass and ceramics program at Pacific Lutheran University in Tacoma. Because there was no appropriate place in the art building, Keyes built the first furnace in his garage. Other schools in Washington—Western Washington University in Bellingham, Washington State University in Pullman, Everett Community College—briefly offered glassblowing classes as well. The hot shop at the University of Washington, run by Richard Marquis, may have been the shortest lived, lasting only from 1970 to 1971. In Oregon, Ray Grim built a hot shop at Portland State University with the help of Dan Schwoerer, who had been a student at Madison and Littleton's assistant. Another program was established at Eastern Oregon State College in La Grande by Tom Diamond. By the late 1970s, with the exception of the facility at La Grande, which is still running, all of these hot shops had closed due to rising costs and the small number of students who could be taught at one time.

Although this blossoming of the glass arts in the schools did not last long, it opened the glass world to many students who went on to create their own studios and introduced students to other artists working in glass. The value of the latter cannot be overestimated.

In factories, glassblowing is traditionally done in teams of three to six people because it is efficient and frequently necessary to have assistance when making complicated forms. Skills and traditions are handed down through years of training with master blowers. Littleton's creation of the small furnace was for the purpose of separating glass work from the factory setting and bringing it into the realm of individual artistic creation. Whereas this freed the artists from the rigidity of factory work, it also left them without the technical knowledge that was inherent in that system. The Americans were forced, therefore, to depart from the use of traditional techniques. The result was

an immense amount of experimentation and innovation, and also a lot of working in the dark. Everything, from how to build furnaces and annealing ovens to how to melt glass properly, had to be devised. Not using the apprenticeship method of factory work also meant that few people knew much about working the molten material. It helped immensely to know what other artists had discovered.

Some, like Michael Whitley, Richard Marquis, and Dale Chihuly, went to Europe to learn more about traditional techniques. All three received Fulbright scholarships, Whitley going to Britain, Marquis and Chihuly to Venice. But they were exceptions. For the most part, people learned by doing. The results frequently looked less like works of art than like amorphous blobs, which Richard Marquis labeled "the school of dip and drip." In the early years, artists were also expected to work alone to further remove themselves from the factory model. In fact, the first two national shows of blown glass, in 1966 and 1968 at Toledo, required the artists to sign an affidavit that they had not received any assistance in making their entries. Still, this did not slow the constant exchange of ideas. Glass artists traveled to workshops all over the country seeking solutions to the myriad problems of working with hot glass and sharing the excitement of it all.

Between 1968 and 1975, there were only a handful of people working independently in the Northwest. In Oregon, Boyce Lundstrom, who came from the program at San Jose State, started a studio in Corvallis, and Dan Schwoerer teamed up with Ray Ahlgren in Portland. In Seattle, Steve Beasley, Marquis' student at the University of Washington, received a two hundred dollar grant from the King County Commission for the Arts to build a portable glassblowing furnace in return for giving public blowing demonstrations. In 1971, Beasley joined with Roger Vines and Rob Adamson to start an arts and crafts cooperative. The co-op, though multimedia at its inception, soon was left to the glass artists alone. Until its demise in the mid-1970s, it provided one of the few places in Seattle outside a school setting for artists to blow glass. Eventually, Beasley, Vines, and Adamson started their own glassblowing businesses, Adamson's becoming one of the key elements in the growth of the artistic community. First, however, came the birth of the very heart of the Northwest glass move- ment, the Pilchuck Glass School.

The Pilchuck Glass School was carved out of the wilderness in the summer of 1971. Probably only Dale Chihuly could visualize then what Pilchuck was to become to the Northwest and to the world of glass.

Chihuly had returned from Venice, to teach at the Rhode Island School of Design. He also taught glass at the Haystack Mountain School of Crafts at Deer Isle, Maine, during the summers of 1968 to 1970, and from that experience came his dream of a similar arts center for the Northwest devoted entirely to glass. Chihuly obtained two thousand dollars from the Union of Independent Colleges of Art. All he needed was a site.

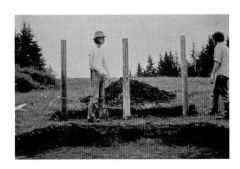

Breaking ground at the
Pilchuck Glass School, Seattle, 1971.

In the spring of 1971, he approached John Hauberg and his wife Anne Gould Hauberg, who were actively involved in Friends of the Crafts and the Pacific Northwest Art Center. Chihuly's passion for his idea caught fire with the Haubergs, and they donated a forty-acre piece of their tree farm, just outside of Stanwood, Washington, complete with a pond and a view of Puget Sound and the Olympic Mountains beyond. John Hauberg also became Pilchuck's chief patron, paying the bills for the next ten years until a broader base of support was finally established. As Alice Rooney, director of the Pilchuck School from 1980 to 1990, explained: "I always thought that Dale and John were a great match. John loved the idea; he loves to build. It was a natural formula."

Building a facility was something of an ordeal the first year. Students from each of the schools in the Union of Independent Colleges of Art came to help, and Chihuly recruited others. Not only did they need to build the furnaces and ovens, but they had to build their own shelters to keep off a seemingly endless rain. Some built small cabins. Others slept in tents, under tarps, or in the backs of cars. Buster Simpson built a shelter in a stump. They cooked over open fires, and they blew glass. Others, intrigued by what they heard was going on, came to look. Fritz Dreisbach, who had been teaching at the Toledo Museum of Art, and who, that very summer, had helped found the Glass Arts Society, visited Pilchuck and by the next summer was teaching there. Richard Marquis came from the University of Washington with some surplus equipment. He looked at the glassblowers, knee-deep in mud, and proclaimed, "This has nothing to do with art and it will never work." He did not reckon on Chihuly's drive and uncanny ability to promote his dream.

According to Rob Adamson, Chihuly never intended Pilchuck to be a traditional school but to be the best glass center in the world where people could share ideas and stimulate one another's work. Chihuly wanted to bring in the most expert glass artists he knew and, using the atelier model, let students learn by watching the artists work and by assisting them. One of Chihuly's great gifts is networking, and he has been able to convince most of the best glass artists in the United States, as well as many from Europe, to teach in his programs. In addition, he has a gift for promoting Pilchuck and the glass arts with collectors and supporters for the arts. Russell Day describes Chihuly as ". . . afraid of nothing. He could make mistakes and it wouldn't get him down. He had an insatiable drive and a capacity for working his tail off." Anne Gould Hauberg remembers that, the second year after the artists had started to build their own shelters at Pilchuck, Chihuly took around pictures of the cabins and actively promoted the school. With his own art, he was an ascending star, and as Hauberg put it, "Dale pulled everything along with him."

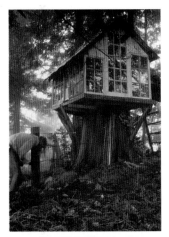

Artist Buster Simpson and his
tree house at Pilchuck, 1972.

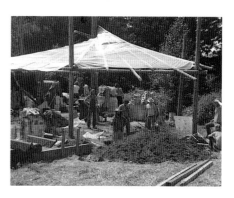

From the beginning, Chihuly preferred working with others. His time spent in Italy only reinforced his belief that one could blow faster, larger, and better when several people worked together. When Chihuly met artists whose work he liked, he invited them to work with him. Many of the young artists who came to Pilchuck ended up staying as members of Chihuly's blowing teams. Benjamin Moore recalls his own recruitment: "My parents sent me to Pilchuck in 1974 as a graduation gift. There was only the hot shop and two old army cook tents. I picked up glassblowing very quickly. At the end of that summer Chihuly, Jamie Carpenter, and Fritz Dreisbach stayed on to work. Dale asked me to stay. I ended up working there for thirteen summers. Pilchuck was the biggest influence in my life because I met so many people and learned so many ways to work with glass. I grew up at Pilchuck."

William Morris, another of Chihuly's team, had been in the glass program at Central Washington University at Ellensburg, and came to Pilchuck in 1975 as a truck driver: "One of my jobs was picking up people at the airport and that was the way I first met Dale. We talked on the way back to Pilchuck where we arrived about midnight. A short while later, I came up to the hot shop. There were some cute girls working out on the pad and Dale was giving them a demo. At first I thought he was just flirting with these women, but I watched the demo that he did and actually it was one of the best I'd ever seen, where he showed somebody how to work the glass without using any tools, just using the natural characteristics of the glass. I thought, this guy really knows what he's doing. So I said, 'I would love to work with you. Do you want any help?' He said, 'Sure. Be on the pad at four in the morning.' We've worked together ever since." This atmosphere of sharing is one of the key factors in Pilchuck's success. It has also set a tone for the whole Seattle glass community, a major factor in encouraging artists to remain in the Northwest, whether or not they have come through Pilchuck's door.

Pilchuck grew steadily through the early 1970s. Tom Bosworth was hired as architect, and the physical campus took shape. Its programs enlarged from a single summer session with sixteen students to five sessions with 255 students in 1990. The latest addition is an "emerging artist in residence" program held after the usual summer sessions have ended. In the process, Pilchuck

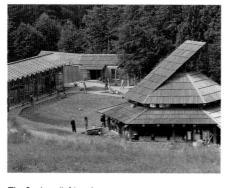

perhaps has become more of a traditional school than Chihuly originally planned. Instructors no longer do much of their own work while they are at the school, but assist the students to master techniques and produce work of their own. Although this may be less satisfying in some ways for the artist/ instructor, it maximizes the learning experience for students.

In return, Pilchuck provides Northwest artists who work there with a yearly source of supplementary income and easy access to the newest techniques in glass art from throughout the world.

Pilchuck, as important as it is, has not been the only force behind the continued expansion of the Northwest glass community. One of the major factors in encouraging artists to stay in the Northwest after coming to Pilchuck was the availability of employment in private studios and production glass factories, which frequently allowed artists to do their own work during off hours. In 1974, Boyce Lundstrom, Dan Schwoerer, and Ray Ahlgren created Bullseye Glass Company in Portland, which specializes in handcast sheet glass and also provides facilities for artists to experiment with fusing and kiln casting. Spectrum Glass, just east of Seattle, in Woodinville, and the largest manufacturer of speciality stained glass in the world, was started by Jerry Rhodes, Don Hansen, and Ron Smids and has been a consistent employer of people from the glass community as well as a source for technological information. But the person who made the biggest impact for artists who were trying to make a living while following their artistic passion was Rob Adamson, through his Seattle company, The Glass Eye.

Adamson, a Washington native and ceramics major, first saw glassblowing in Mexico and South America where he had set up arts and crafts and fishing cooperatives while in the Peace Corps. When he came back to the Northwest and met Roger Vines and Steve Beasley, it seemed a natural step to create the arts and crafts cooperative with them. From 1973 to 1977, Adamson learned more about glass by working summers at Pilchuck and winters as a technician at Spectrum Glass. He also briefly managed the Genesis glass factory in Portland and his own company, San Juan Art Glass, in Seattle. But it was not until 1977 that his glassblowing and his talent for business really merged in The Glass Eye.

Adamson quit his job at Pilchuck and decided to open a retail shop on Post Alley near the Pike Street Market. After all, there were a growing number of glass artists who needed a place to market their work besides at street fairs. He soon became bored and decided to build a furnace so he could blow glass while minding the store. Charlie Parriott, who came to Pilchuck in 1974 and worked at Spectrum, was the first to work with Adamson at The Glass Eye. Three other employees joined them: Walter Lieberman and Sonja Blomdahl, artists from the east coast, and Mark Graham, a musician, whom Adamson claims he hired to tell jokes and play music while the others worked.

Adamson and his colleagues soon realized that trying to work in a small, very public, retail shop was difficult at best, and in 1979 Adamson moved the blowing studio to an old church on King Street. The first three years of the business were a struggle. They mostly made lamp shades, which Adamson peddled up and down the west coast out of his VW van, wiring the money back to the Eye so they

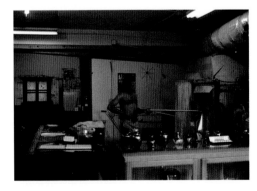

Artist Therman Statom
working at the first Glass
Eye, Post Alley, Seattle, 1978.

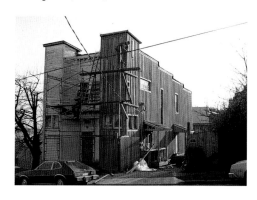

could continue production. "Originally I had no intention of making stuff for sale. I only wanted to do artwork," claims Adamson. "But part of my dream was to get a factory going where young people could learn, graduate, and go on to do their own work. Sometimes people would joke that I only increased production so that I could hire more artists. I was really just having fun. For the first three years I lost money. But when I saw my employees getting married and having kids, I worried I couldn't keep them employed. At the time, there weren't many other places for them, so I became determined to make it work, and the business got a hold of me and taught me what I needed to do."

The Glass Eye provided a bridge for artists between going to school and working independently. Northwest artists who passed through The Glass Eye include Blomdahl, Lieberman, and Parriott, as well as Richard Royal, Benjamin Moore, and Dante Marioni, who started working there at the tender age of fifteen. When The Glass Eye moved to its location on the ship canal between Lake Union and Puget Sound, Ben Moore bought the old church for his own studio, where Royal and Marioni still come to blow.

Early blowing studios that also maintained retail shops on the premises not only provided support for artists but were instrumental in educating the public about glass. Prior to 1970, the Northwest public had seldom seen art glass and hardly knew what it was. In 1972, when Eric Brakken, Greg Englesby, Tom Andre, and Dave Stone opened Glass House Art Glass in Pioneer Square in Seattle, "people would come through," Brakken says, "and ask us why the pottery was transparent." Glass House, with its blowing facility open to public view, is the oldest continuously running blowing studio in the Northwest and probably the place where more people have been exposed to hot glass than anywhere else. A similar facility in Oregon, the studio of Bill and Sally Worcester in Cannon Beach, provides the same kind of familiarity for visitors to that coastal town. In the early 1970s, these studio/shops were about the only places in the Northwest where one could buy glass. Art galleries

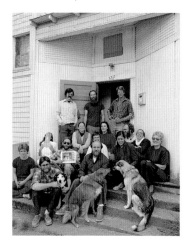
Rob Adamson (center front) with the Glass Eye Crew, 1980.

still classified glass as a craft and generally refused to show it.

"When I first started here in 1980," Alice Rooney says, "my perception was that Pilchuck was better known in New York than in Washington." Undoubtedly that was true, despite the fact that a group show of Pilchuck artists was organized in 1973 in Seattle by the Pacific Northwest Art Center, and Marquis and Chihuly both held solo shows in Seattle prior to 1978. During the 1970s, however, support for the glass arts quietly grew within the already strong public arts programs. Paul Marioni, who does architectural glass as well as blown and sculp-

tural glass, claims it was Seattle's reputation for supporting regional artists with such public programs as the Allied Arts of Seattle's "1% for Art" that induced him to leave northern California where he was already established.

By 1978, this support was manifested in the city's creation of the Pratt Fine Arts Center. This facility, designed for "the fire arts"—metalworking, ceramics, jewelry making, and glassblowing—was under the auspices of the Seattle Parks Department. Artists who needed studio space but could not afford expensive glass furnaces and annealing ovens could rent their use by the hour at Pratt. In turn, the artists instructed others who wanted to learn the craft. The city eventually found Pratt too costly to operate and released it to become a nonprofit organization. The center now is run by a volunteer board and receives operating funds from various sources, including city, county, and state arts commissions. It remains open year-round to anyone who has an urge to find out what it is like to handle a blowpipe, slump glass, or bend neon tubing.

Just as the majority of the Northwest glass artists have been to Pilchuck, an equal number have worked or taught at Pratt, which has promoted the glass arts in every way on a local level. There have been many times when Pratt has faltered, but the value of this unique facility has been shown in the continual support for it from the glass community at large.

Although glass had largely moved out of public institutions in the Northwest by 1982, support was emerging from the private sector. Through education and promotion, Pilchuck, Pratt, and local galleries prompted collectors to see glass not only as inherently beautiful, but as a medium for art. Auctions held by Pilchuck, Pratt, and The Glass Eye exposed viewers to what and who was new and often gave them a chance to buy work at bargain prices. Pilchuck's seminar for collectors and Pratt's lecture series offered further encouragement and education. Glass became a Northwest specialty.

Corporations such as SafeCo, the Sheraton Hotel, and Seafirst built collections of glass for their public and private spaces. In 1989, the Prescott Corporation purchased thirty-six pieces to act as the drawing card for the public areas of its new Seattle building, the Pacific First Centre. Called the Prescott Collection of Pilchuck Glass, it includes two large installations, one by Dale Chihuly and another by William Morris. According to Dick Clotfelter, Prescott's president, "Its worth is measured more by the public reaction than in dollars. There are sixty to seventy people per weekend in the building just to view the glass."

The degree of public interest present in Seattle and growing rapidly in Portland is indicative of the way glass has captured the heart of the Pacific Northwest. Since 1980, galleries in Seattle regularly showing glass have grown from three to eleven. The Bellevue Art Museum frequently includes glass exhibits; the Seattle Art Museum has held a

The hotshop at the
Pratt Fine Arts Center, Seattle.

solo show of Chihuly's work and, in the spring of 1989, presented its first group exhibition of Northwest glass artists. In Portland, the Contemporary Crafts Gallery organizes glass shows, and more galleries are making glass a major part of their trade. Further acknowledgment of the Northwest's status within the national glass scene came in the fall of 1990, when the Glass Arts Society appointed Alice Rooney its new director and agreed to move its headquarters from Corning, New York, to Seattle.

Educational and work opportunities are also increasing. In 1985, Boyce Lundstrum opened Camp Colton in Colton, Oregon. The school offers instruction in all forms of glass, with the exception of blowing molten glass, and encourages students to acquire a broad knowledge of basic glass technology. Plans are afoot to open another school in connection with the Oregon School of Arts and Crafts in Portland, which would give special emphasis to kiln forming and fusing. Chihuly's new studio, on Lake Union, The Boathouse, employs nearly as many artists as The Glass Eye, some of whom move between one studio and the other depending on each studio's needs. The Pratt Fine Arts Center is thriving, and the growing number of small studios provide more work and space for artists who want to trade work time for studio use. In addition, Pilchuck offers residencies to artists who do not work in glass but who want to explore how the medium can fit with their art. More people are thus drawn into the circle of glass artists, which continues to broaden and expand.

Around the whole weaves the one factor commonly overlooked by observers, but frequently mentioned by artists—the climate and the beauty of the Northwest itself. Ginny Ruffner talks about the creative influence of Seattle's "oyster light." Charlie Parriott describes coming to Pilchuck: "I drove across country with my dog, planning to be there only for one session. As soon as I got across the Cascade Mountains, long before I got to Pilchuck, I took one look around and decided I was going to live here." Richard Marquis, when asked if he still taught much at Pilchuck, stated, "The main reason to come to Pilchuck is to get to the Northwest, and I'm already here."

The moderate climate of Oregon and Washington is, of course, a boon to glassblowers, who must deal with dipping into furnaces heated as high as 2,300°F. But beyond that, most of the artists find a strong connection with the Northwest's natural wonders: the shimmering transparency of coastal waters and inland lakes, the stillness of evergreen forests, the ruggedness of mountain peaks thrust out of the fire of molten rock below. As Mary Van Cline, who moved here in 1985, explains: "It was ten degrees in Boston. I called a friend in Seattle and she said the flowers were blooming. I came here and went camping out on the Dungeness Spit where there were all these gigantic, bleached pieces of driftwood. It looked like a giant's playground. I felt like I could come out here and be inspired for the rest of my life."

CONTEMPORARY

GLASS ARTISTS

SONJA
BLOMDAHL

Lately I have been letting color dictate what the form will be. Some glass colors are soft, others stiff in the way they work when they are hot. Blue and black, for instance, are softer than red or yellow, and will blow out more easily. I've come to know what the colors like to do and now don't try so much to force them into a shape. This makes the blowing less stressful and more like having a conversation with the material. I can be more open to whatever comes rather than being disappointed that a piece doesn't look like what I pictured in my mind. I'm still in control, but I'm not making something do what it really doesn't want to do.

Symmetry is essential for me. I guess that's just my way. I like things balanced and have a need for that. With so much chaos around us, having an object that is predictable and serene is something I can use in my world and hopefully something others can use in theirs. It took me a long time to realize I *wanted* symmetry; it wasn't that I was just practicing at keeping the work on center. I realized awhile ago that working symmetrically was where I made my niche. In the 1970s, everybody else was rolling glass on the floor and beating it up. I wasn't compelled to do that—and in not doing it, I stood out.

I guess I am not afraid to make something pretty. I don't worry about my work being labeled "decorative." I just want to make the most beautiful object I can. Nor do I mind that it is a vessel. I like that. If someone wants to use it functionally, that's fine with me as long as they respect it. People have told me, "So-and-so has your bowl by their toaster with bananas in it. Doesn't that bother you?" But I like being practical and having nice things around me. I use them, too.

facing page:
CITRUS/BLUE PINK BOWL
1989
Blown glass
7½" × 15"

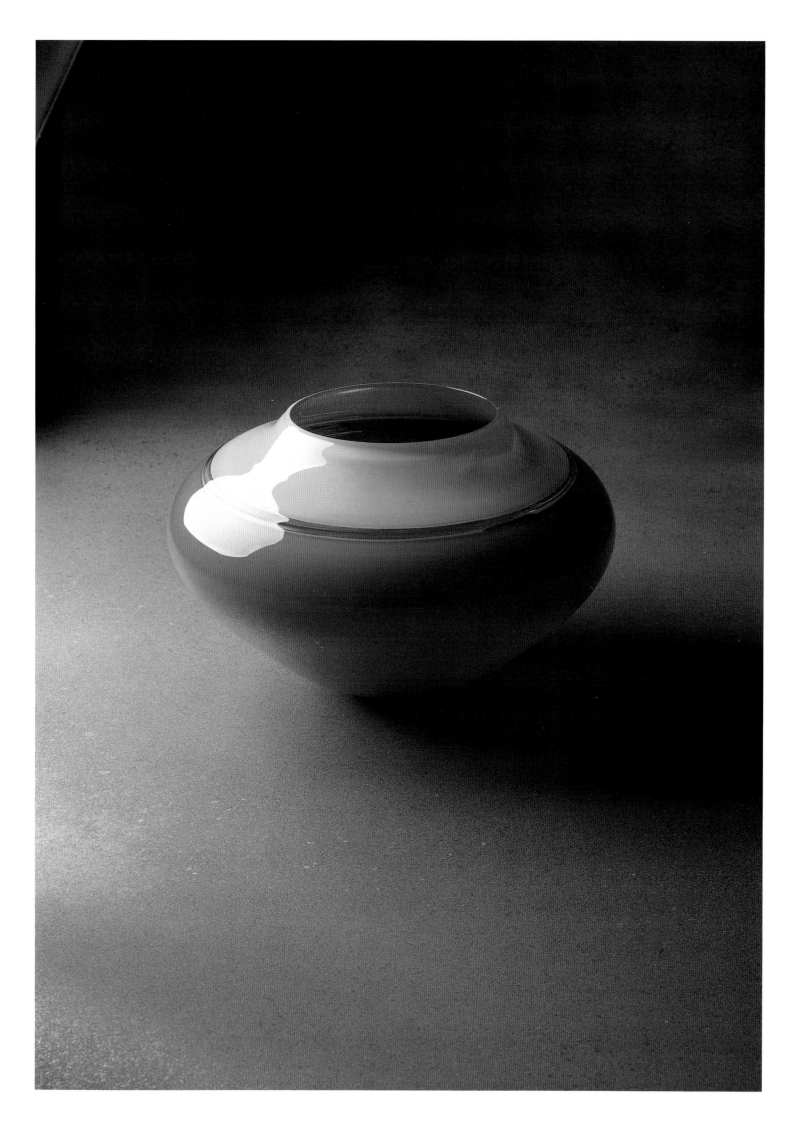

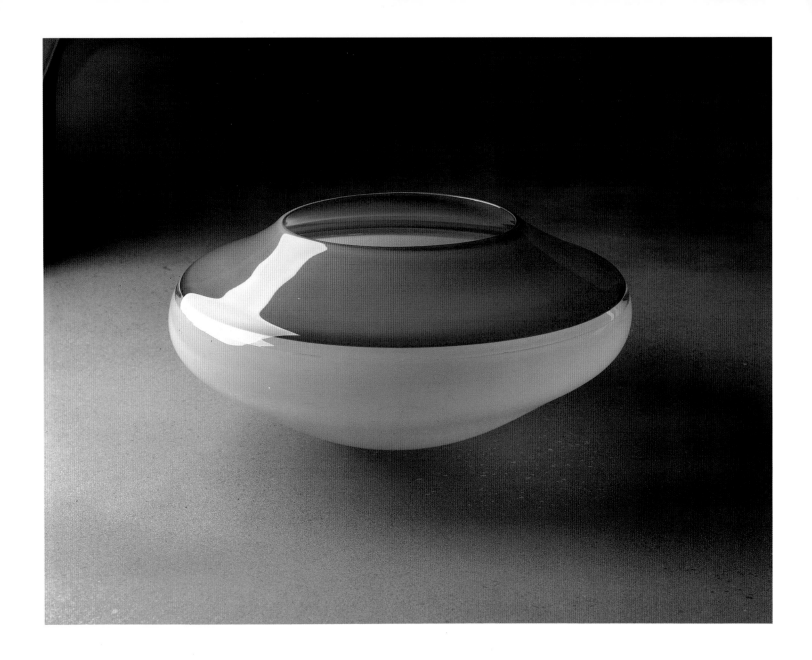

above:

LAVENDER/EGYPTIAN GOLD BOWL

1989

Blown glass

8½" × 13"

facing page:

CHERRY/VIOLET BOWL

1990

Blown glass

8" × 14"

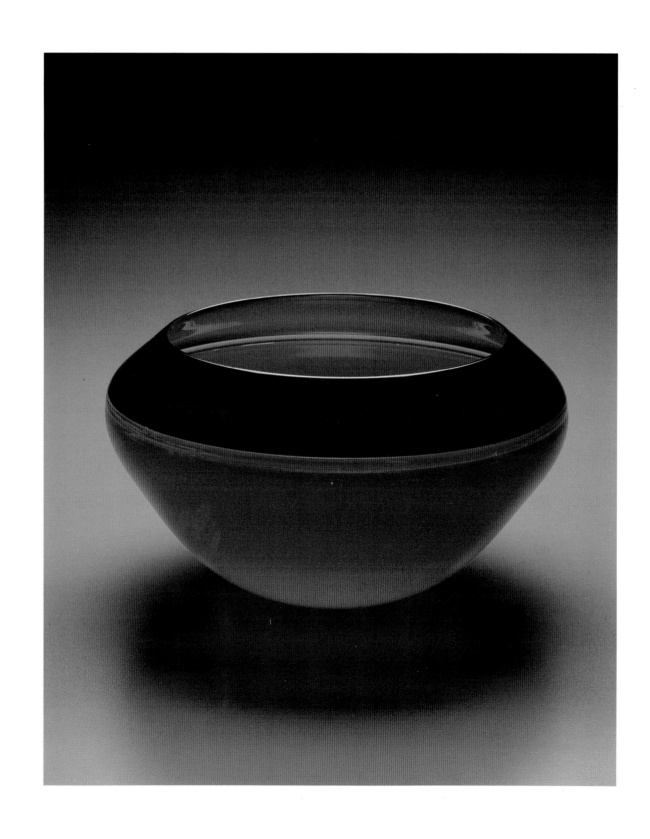

RUTH BROCKMANN

The masks and cast work are all a part of learning more about myself. For a time, when I was doing the masks, I was dealing with the element of hiding and revealing. Now I don't feel I have to hide because I am not at that same point. But I don't have to give up the masks just because I've moved on in my personal development. I can see them differently, as simply a wonderful way to communicate.

My work is concerned with self-realization and discovery, and communicating with and about nature. The only way for self-realization and planetary awareness to come about is by acknowledging the interrelatedness of all living things. In my work there are symbols from cultures around the world. I choose what I like. I think, however, you need to be careful with symbolism, not to have too much or to be too specific. In myth, ancient symbolism, and primitive cultures, there is a tremendous abundance of spiritual energy. I hope that comes out in my work. When I feel that energy, and the viewer picks up on it as well, then the art works.

facing page:
TREE OF LIFE I
1991
Kiln cast glass,
black walnut base, metal
34″ × 18″ × 10″

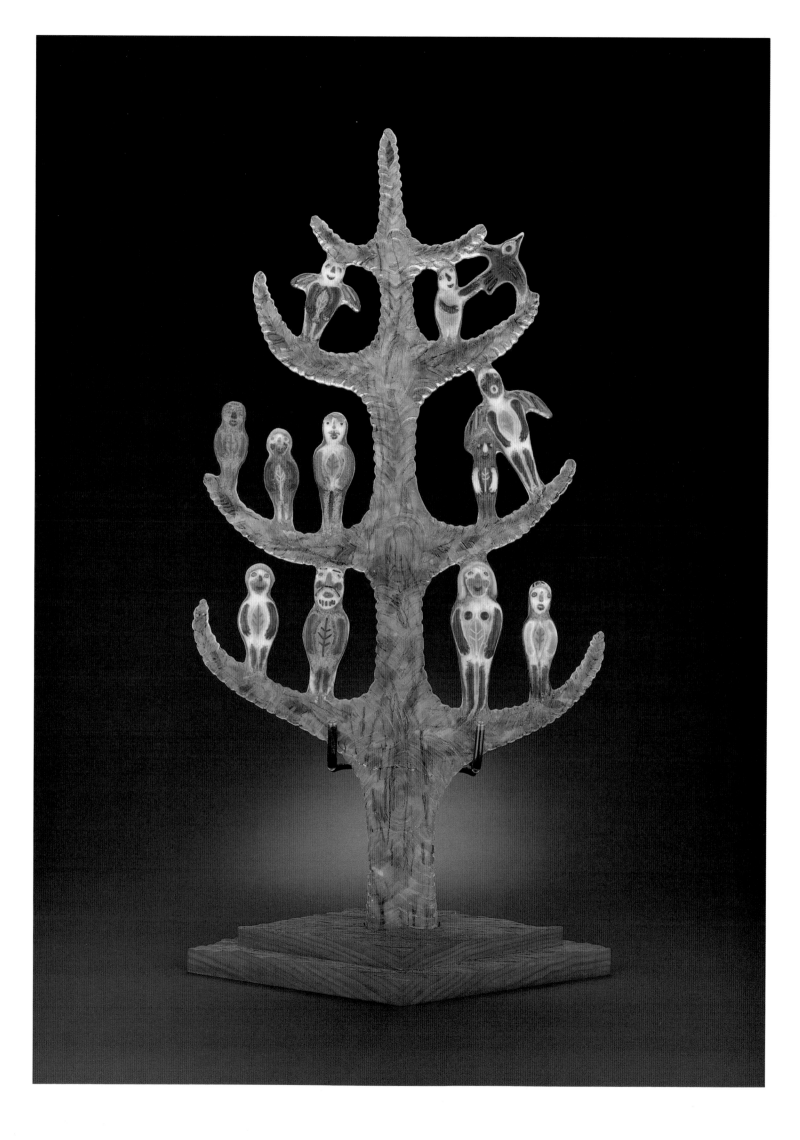

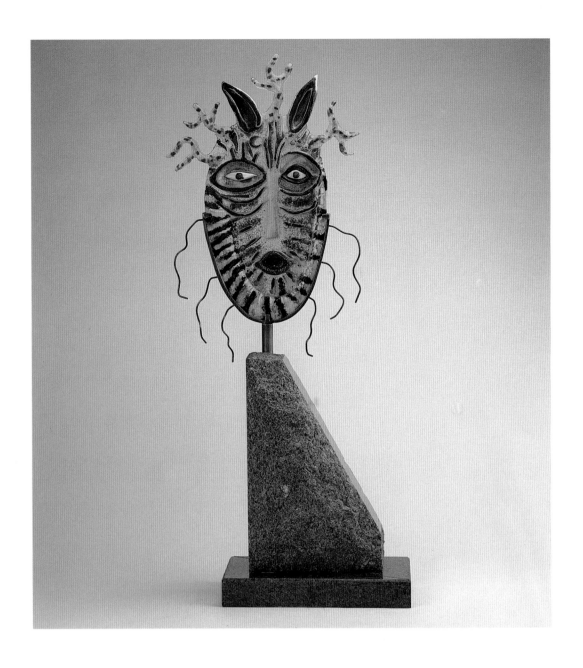

above:

MOON DEER RENEWAL

1989

Kiln cast glass, metal, granite

41" × 18" × 7½"

right:

BREATH OF LIFE

1989

Kiln cast glass, granite

18" × 20" × 8"

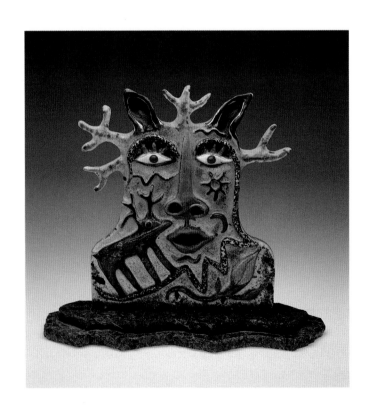

ROBERT CARLSON

Art for me is a mystical process. It is a process of exploring the depths of the human being, and it is in this process that I seek the creative side of myself. For me, the creative side and the mystical side come from the same well, and making art is a way to connect with the mystical. My influences, more than artists, are Jung, Joseph Campbell, religious folk art, and shamanism. I have always been interested in what Carlos Castanada called the "separate reality," not in knowing about it, but in experiencing it. The experience I seek is the numinous, mystical essence of being. I'm not interested in anything else. The rest of it is all show, all surface.

For me, what separates Western mysticism from Eastern is not so much the Old Testament as it is the strong naturalistic and pantheistic roots of the West. It is the same kind of spirit that the Native Americans had, a pointing to one's ultimate place in the world. I want to live in a world where I belong, and to be connected to everything in it—the people, the animals, the rocks, the stars, all the space in between. My art is a relationship, too. I have to ask, "Is my art an integral part of my life? Does my making art have as strong a foundation to my life as water does to the ocean or rain to the flower?" It's that kind of cyclical, inclusive relationship that everything has to have for any one thing to be.

I find making art incredibly difficult. For me it is a process of intense self-questioning. Oftentimes, I question the very foundation of whether or not I should be an artist. This doesn't happen once in a while; this happens a lot. I have found that, unless I can freely say "yes" with all of my heart to making art, essentially all I'm working for is image, or something else. Maybe it's about fame, or looking good, or success, but it's not about the deep down place. It is not finding the hidden well. That well is what I seek and from where my art springs. I know as soon as I lose that, I am lost.

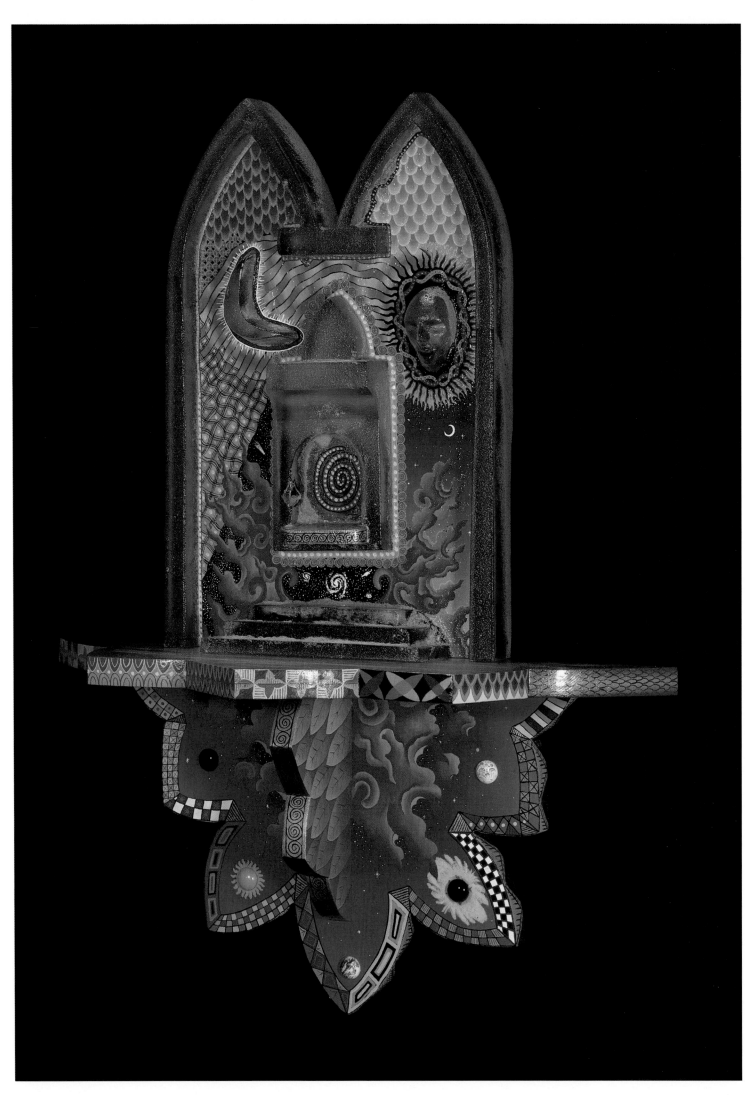

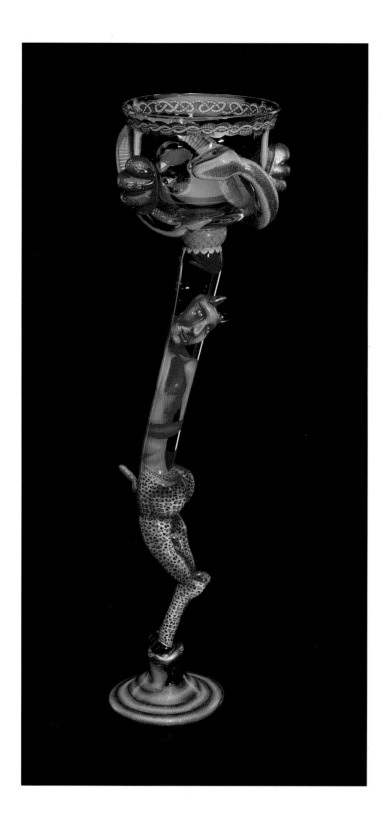

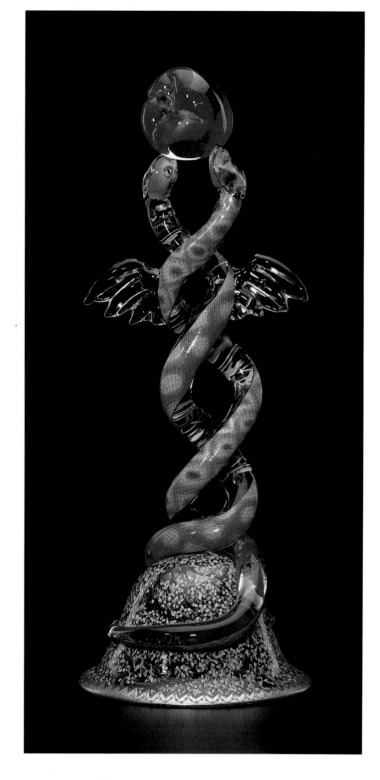

DALE CHIHULY

Glassblowing is an ancient craft developed by the Romans two thousand years ago. Traditionally, it has always been done in teams of three to six people. Most of the glass I make is created similarly to how it was done then, except that my teams are sometimes as large as twelve to fourteen people simply because the scale is larger and the pieces are more complex.

People ask, "How does the team work?" and "How are you able to direct the team?" It's not easy to explain. I sometimes make the analogy of myself as a filmmaker. First of all, I come up with a concept which might be like a script. I don't work on the team itself but make drawings while the team is working. The whole process is a very exciting and inspiring one, and it is the time when I do all my drawings.

People ask me if I get too removed from the process because of its complexity and the numbers of people involved. But when the numbers involved in making a film increase, it doesn't necessarily put the director further away from the concept of the film. Having the support and skills of a large team can be tremendously gratifying. I feel very fortunate to be able to have such talent at my disposal, especially now that I am getting more involved with large architectural projects and installations. I suppose it would be possible to do these things on one's own, but the whole process would just be too slow for me. Glassblowing is a very spontaneous, fast medium, and you have to respond very quickly. I like working fast, and the team allows me to do that.

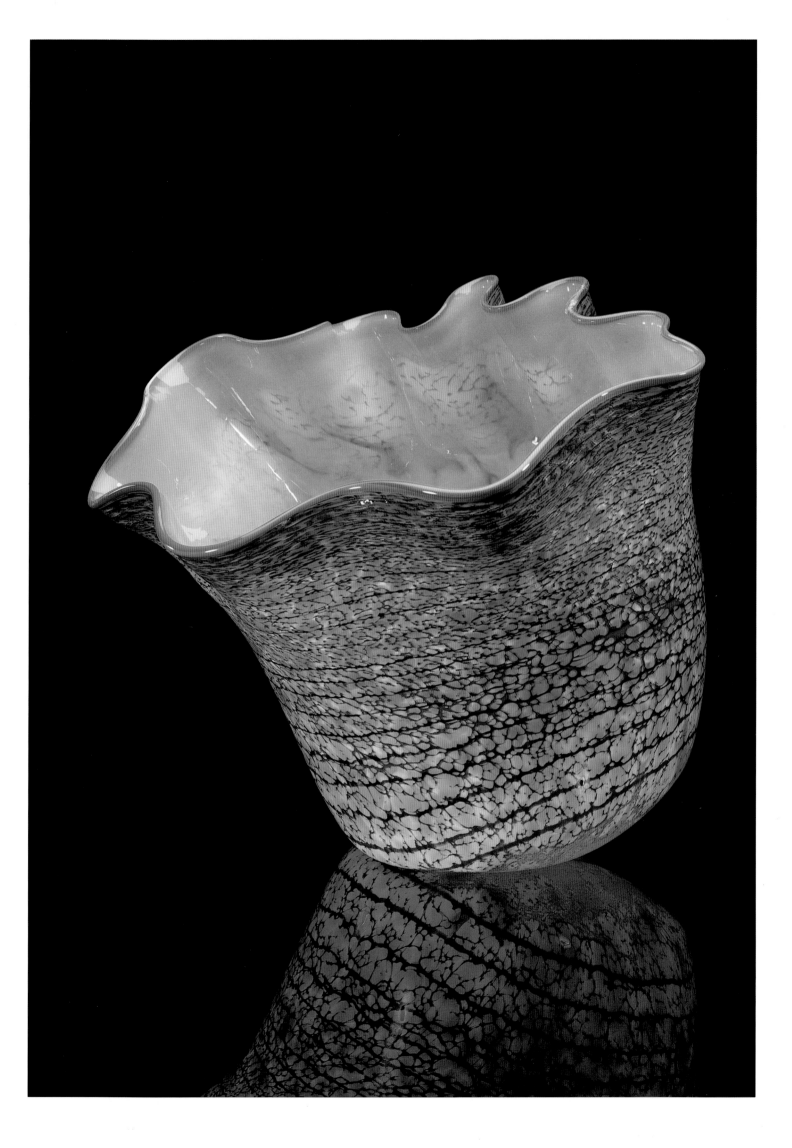

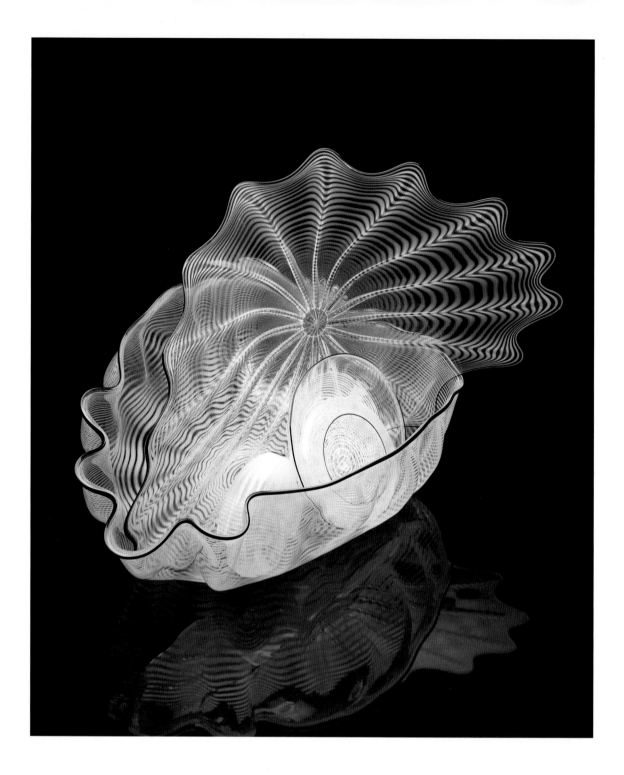

above:

WHITE SEAFORM SET
WITH BLACK LIP WRAPS
1990
Blown glass
14″ × 25″ × 19″

previous page:

CADMIUM YELLOW MACCHIA
WITH PINK LIP WRAP
1990
Blown glass
19″ × 21″ × 19″

below:

**COBALT BLUE VENETIAN
WITH TURQUOISE LEAF**
1990
Blown glass
25″ × 17″ × 16″

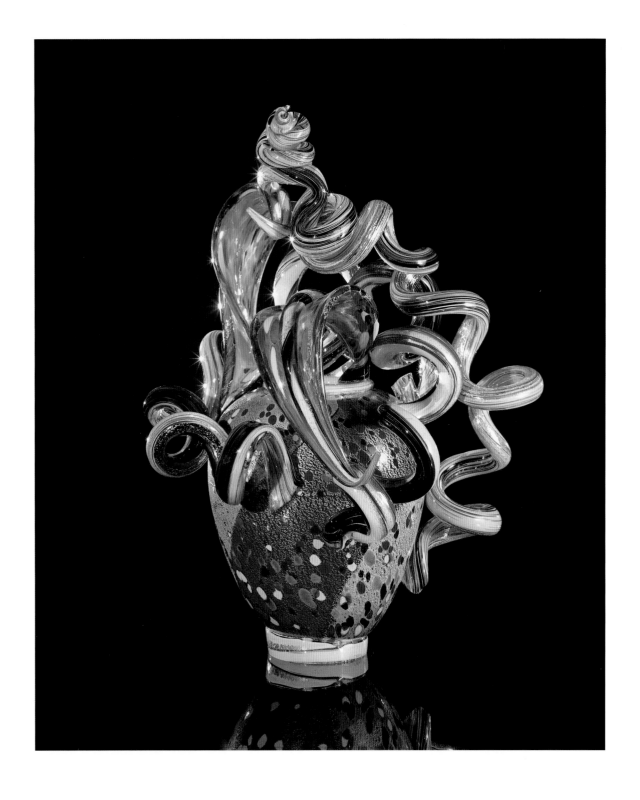

KéKé Cribbs

My figures have a certain humor depending on how I make them feel, how I "dress" them, but the glass window inside of them is always the most animated part. In a way, I see the wooden portion in my pieces as being abstract, even when it defines a figure. I can do anything I want to with the paint: I can be figurative, or decorative or abstract. But when I get to the glass, where I am really putting the drawing, then I am saying something more specific. All the imagery and symbols are there.

In a sense it's the same way I see people; we have this facade that protects how we are on the inside. I know I consider myself an open person, but there's a part of myself I never offer because I don't think people would understand. That is how I see the windows in these pieces; they reveal the inner spirit, the person you want to be in your dreams, the warrior within.

My ultimate goal in the voyage of my art is not only to succeed in this practical world of making a living, but ultimately to work and work and work until I'm only talking to myself, where everything that is coming out is pure, not influenced by anything except what is in my heart.

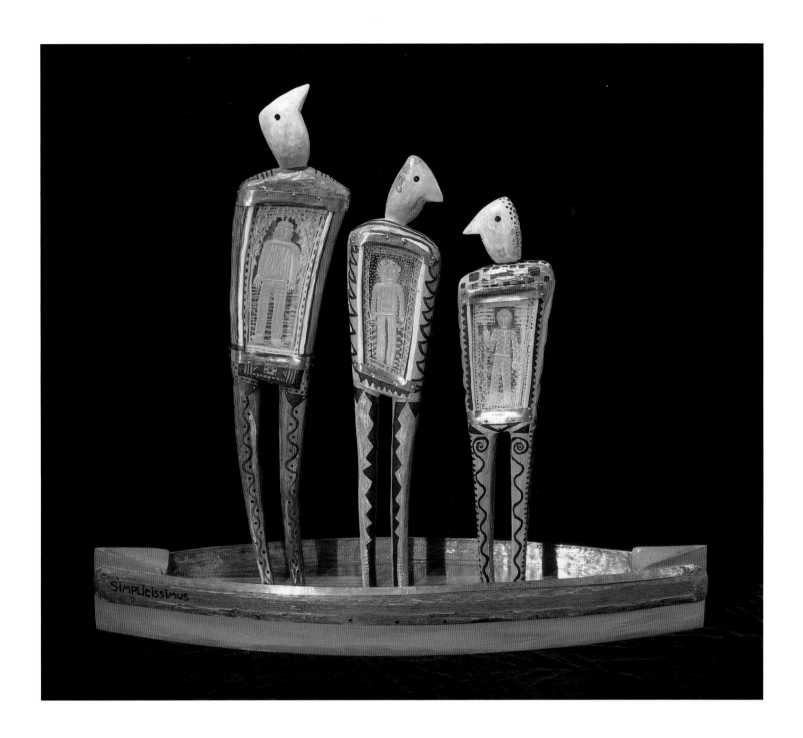

above:

SIMPLICIMUS

1989

Wood, paint, sandblasted glass

24″ × 21″ × 7″

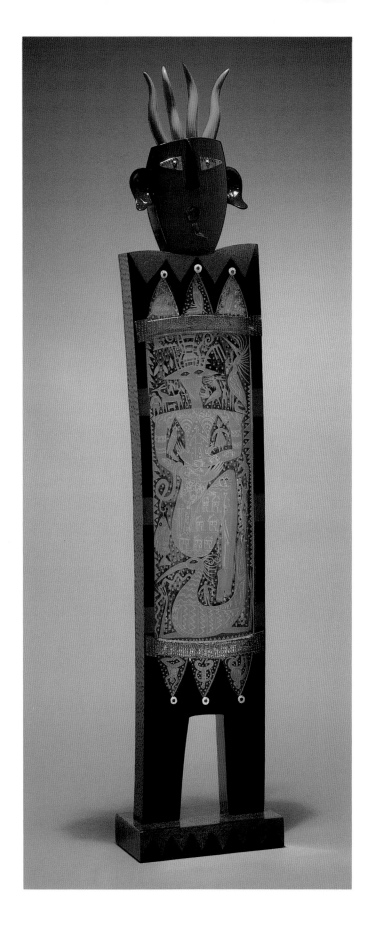

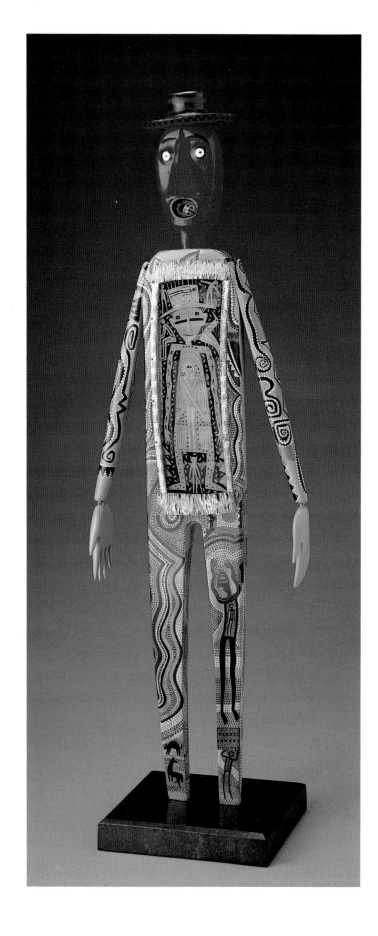

above left:

PALOMA

1988

Wood, paint, sandblasted glass

55" × 10½" × 5½"

above right:

CABALLERO

1990

Wood, paint, sandblasted glass

38" × 12" × 7"

FRITZ
DREISBACH

The *Mongo* series came about in the late 1970s when I found myself making very slick, symmetrical, tightly controlled pieces. When I was giving my slide shows, I realized I kept talking about the wet and fluid look I liked about glass, but the pictures weren't demonstrating this. So I looked at my slides from ten years earlier, and there was that wet look I liked. Part of the reason those pieces from the 1960s were the way they were was because I couldn't blow any better than that, and the glass was sometimes just about to roll off and fall on the floor. I thought the best way to re-create that quality was to let the pieces get out of control again, to make them big and heavy. Then they would start telling me what was going on, and I would respond to that movement.

One of the unique properties I love about glass is its constant change in viscosity with variations in temperature. As glass cools, it gets thicker and stiffer, but the process of stiffening is very slow compared to molten steel, molten silver, or molten rock. Those materials hold the temperature constant while the molecules within them line themselves in rows and columns like soldiers on the field. Once they are lined up, the material becomes crystalline and changes suddenly from a liquid to a solid. Glass never does that. It never crystallizes. The molecules never organize themselves into a pattern or structure. They are just as random in the hard, cold, rigid pieces as they were when they were molten in the furnace. The molecules just simply stop wherever they get frozen, just as if a ballet were stopped right in the middle. That's what glass is, and what I want my work to say. That is why I gave birth to the *Mongos*.

With the goblets I need to take a whole different physical approach. I have to be on my toes and my fingertips, and use thin, delicate tools. The goblets are faster to do, so I can do more of them. There is a lot of set-up time to make the *Mongos*. In addition, they are huge pieces. I have to sit there and wait and wait for them to cool down. Most of the excitement is right at the end. In the last three minutes, two minutes, minute and a half, the piece literally blooms. But I don't prefer one style of work over the other. Both the goblets and the *Mongos* are important to me and have to be done. I show them both, and I refuse to give up either one of them.

facing page, top:

CHAMPAGNE OR COGNAC REVERSIBLE GOBLETS

1980 to 1990

Blown glass

8" to 11" high

below:

GOLDEN MONGO COMPOTE WITH

MULTI-HUE FILIGREE

AND CAST FOOT

1986

Blown glass

10½" × 20" × 18"

facing page, bottom:

RUBY "WET FOOT" MONGO

WITH KISSING SNAKES AND

LILY PAD OPTICS

1990

Blown glass

18" × 19"

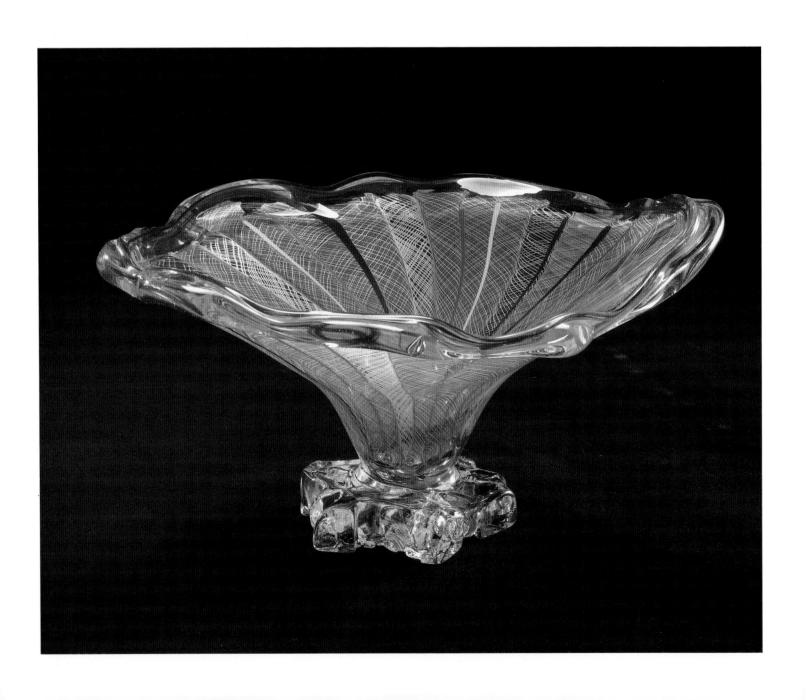

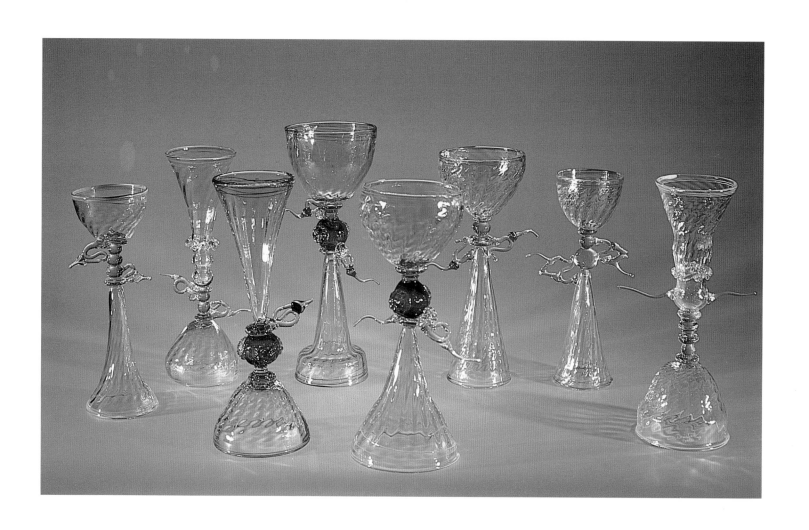

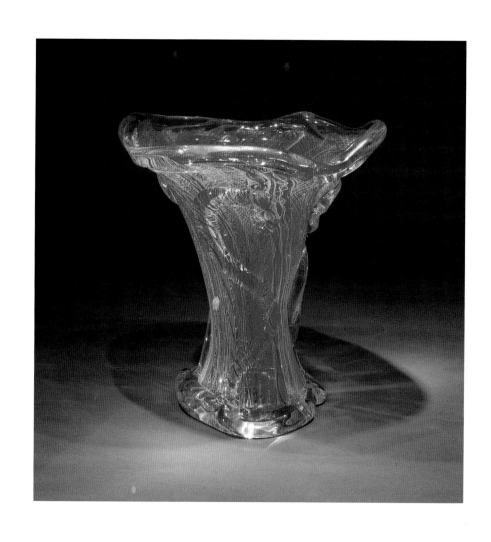

STEPHEN DALE EDWARDS

I work in all mediums at once, glass, paint, steel. It's refreshing for me to do that. If I do a painting that takes a long time and I am sitting a lot, then I want to work on a sculpture that requires me to be very physical or a wood carving where I am swinging a mallet or using chisels so that I'm getting a lot of exercise. Switching around feeds my creativity.

I like working spontaneously and a little on the edge. Somebody who used to watch me blow glass told me that I came to life when the glass got out of control, when it fell on the floor and I had to save it. That is true because then I am free to play with the glass, to experiment, to really open to change. In the cast pieces, the spontaneity comes in working with the clay, which I use to form the plaster molds. I have taken distorted pieces of clay out of molds and thought that they were much better than what I originally started with, and so have taken those pieces and remade the molds with them. It's that cliché of listening to the material and changing your idea in the process.

I have to find the balance between experimentation and techniques I know will work. I don't want to experiment so much that I produce failures all the time, but I like to push the work a little bit beyond the predictable to stay interested. When the learning curve starts dropping, I know it's time for me to bail out.

facing page:

VULNERABLE TRAVELER
1989
Glass, wood, metal
96" × 30" × 19"

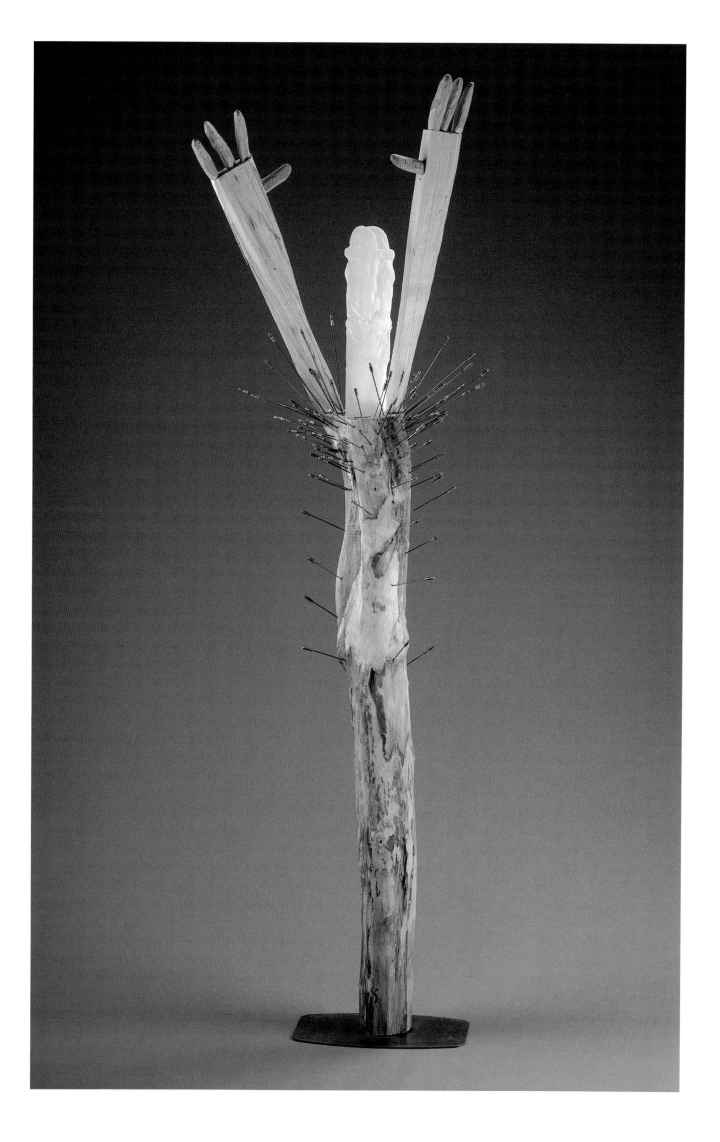

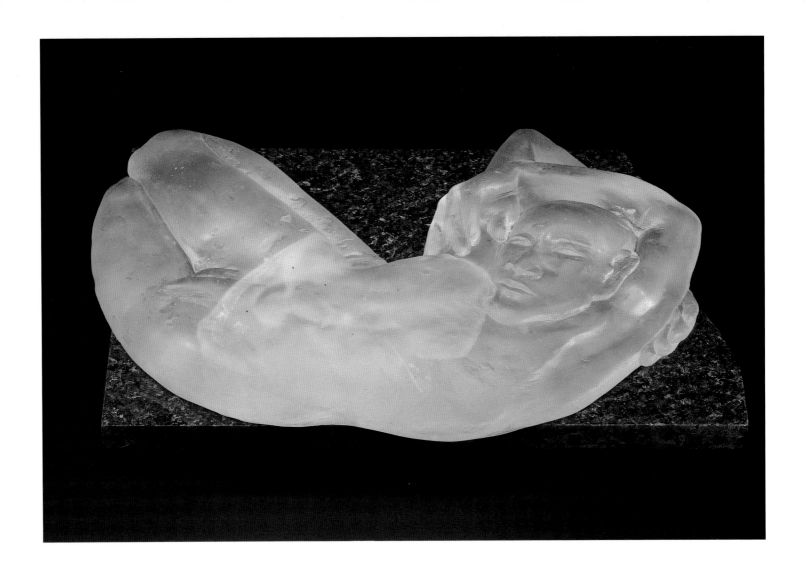

above:

FOLDED DANCER

1988

Cast optical glass on granite

61" × 17" × 30"

below:

HOSTAGE

1989

Cast optical glass on granite

20¾″ × 8″ × 10″

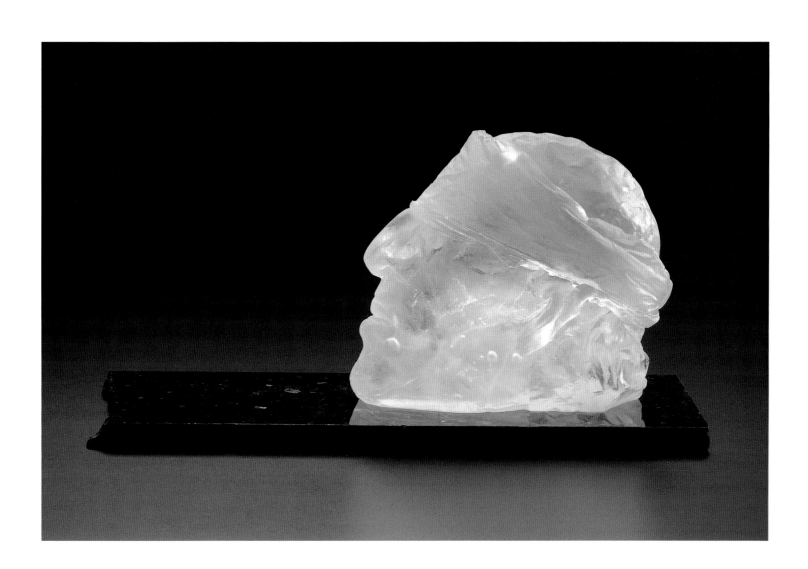

ANN GARDNER

I never manipulate the glass cold. I view it as a molten element, and I try to do everything in the hot process. There is this moment in time with glass, between when you cast it and when it sets up, when you can play with it. It's actually quite long, maybe thirty seconds to a minute. Glass in its molten state has an elasticity that no other material has. There is an immediacy, and a fine line between controlling and not controlling. I've never been around another material that has a time frame during which you can get away with poking it, moving it, bending it, and then, bang, it is set. You have a representation of the energy that went on, frozen in time.

I like that aspect of the material. It allows me to be really direct with it. I could prepare for these castings for hours, but when I go in there, it happens quickly, and the decisions are made right from the top of my head. I don't have time to analyze anything. I am moving with the process, and when I am done moving with it, it's over. That is why I don't want to work with glass cold. It's like a dance that I do with it. Why would I want to change that dance?

facing page:
WINGS AND WOOD
1989
Cast glass, copper, wood, steel
70″ × 30″ × 30″

44

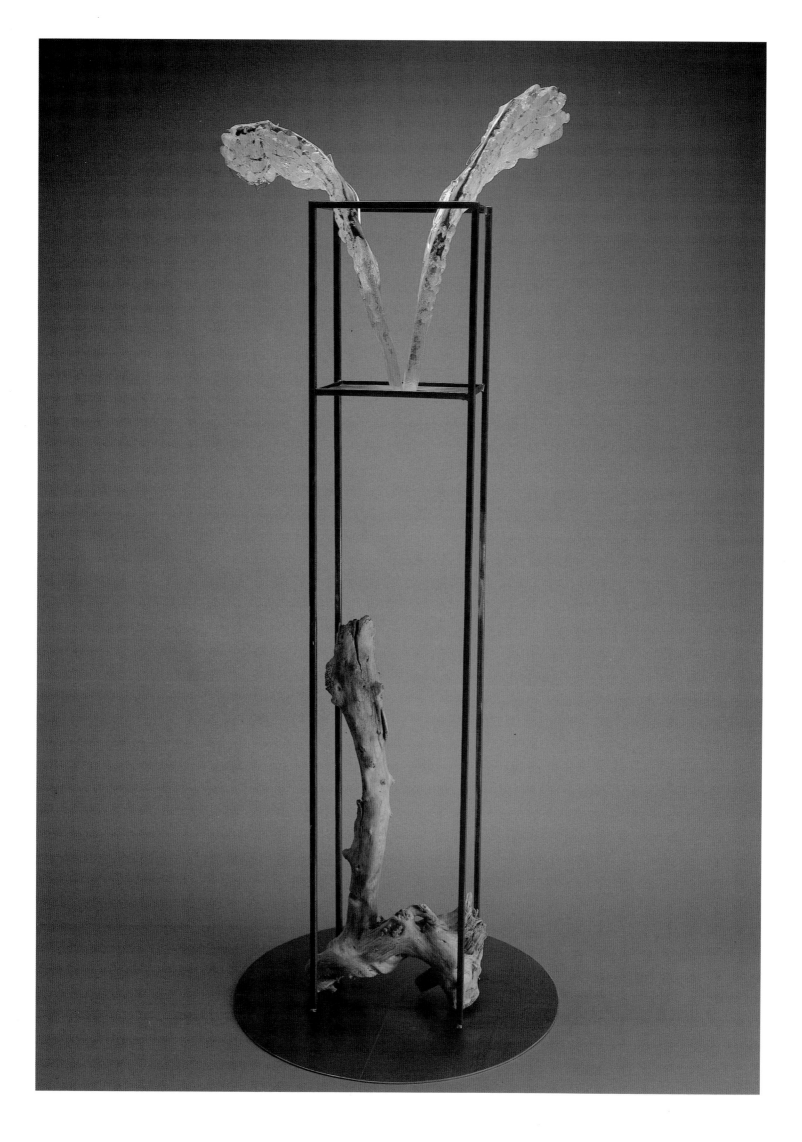

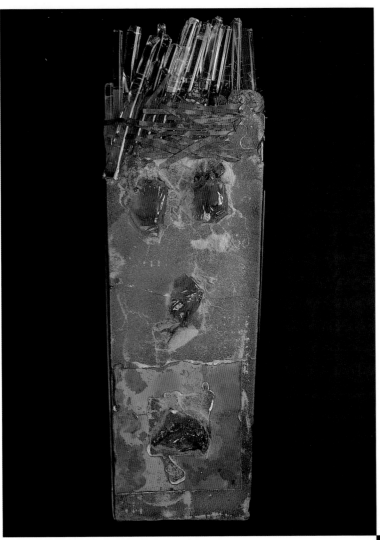

above:

UNTITLED (GREEN)

1987

Sand-cast glass, copper, pennies, paint

11″ × 33″ × 3″

right:

UNTITLED (SILVER)

1989

Sand-cast glass, copper, paint

11″ × 33″ × 3″

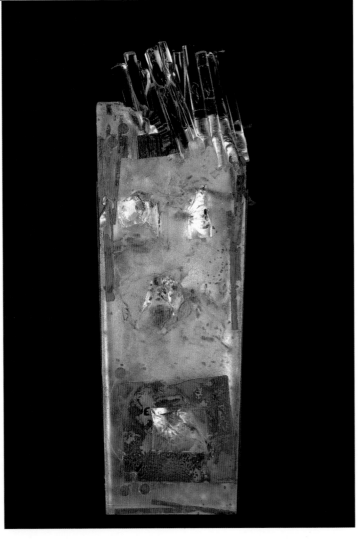

DAVID HUCHTHAUSEN

Each piece is special for me. Each has a different reason why I start it, a different interaction between the light and the glass, different angles, different colors. The most recent pieces still have the focused shadow projections, but what I'm beginning to do is project the color down into the blocks of glass. The substructure actually becomes illuminated to a degree. It takes on and pulls down into it a pale violet or light blue cast.

One of the specific qualities that I have concentrated on for years is the interaction of light with glass. As far as I'm concerned, the light is part of the piece, and until that interaction takes place, the work is not complete because the light adds a whole other dimension. But I don't give light priority over color or over the glass. All are equally important in the final piece.

Many influences have permeated my work over the years. Among them are my architectural background and my interest in spatial relationships, confinement, containment, and structure. These have been juxtaposed to an interest in primitive art and religion. The work I do is kind of in the middle of all that, but I prefer it to remain enigmatic. I have never, probably will never, give out all the information on what a piece is about. I think the work has to stand on its own if it is going to have any real importance. My pieces aren't about just one thing. They are about developing separate response mechanisms in each viewer so that the pieces take on lives of their own.

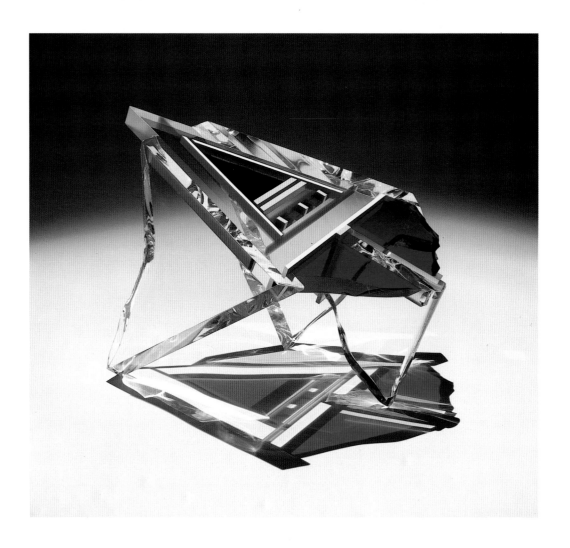

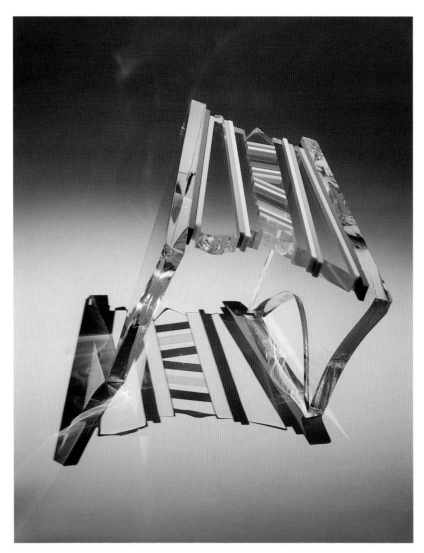

above:

THISTLE

1988

Laminated glass

22″ × 14″ × 13″

left:

LEITUNGS SCHERBE 86C

1986

Laminated glass

22″ × 12″ × 17″

facing page:

RECON

1990

Laminated glass

22″ × 13″ × 9″

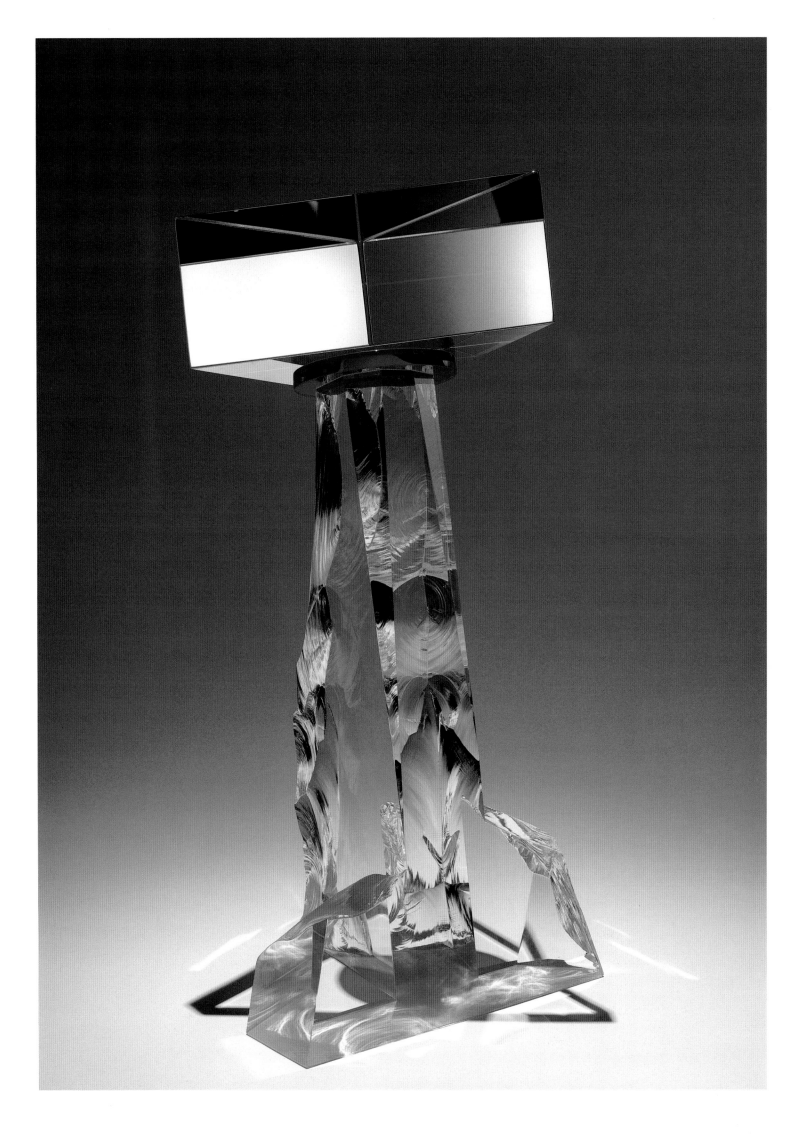

JOEY KIRKPATRICK & FLORA MACE

Joey: If you told us eleven years ago, "I've picked out somebody I want you to collaborate with for the next ten years," each one of us would have said, "You've got to be kidding! I'm not interested." But it just sort of fell into place. During the first month we started working together, we said it was my work, and Flora was helping me. But that didn't work well for very long. I needed Flora's help, but how long was she going to be willing to help with *my* work? I remember we left the hot shop and went for about a four-hour ride, and we said. "Can we do this collaboration?" It scared us to death. But it has worked.

Flora: In our small way, we're a company. We're artists who have some of the same visions. And Joey has a tool that makes my energy stronger and vice versa. She has a fabulous hand for drawing. But I've always enjoyed putting things together. Give me a piece of paper and a pencil, and I feel as if I can't do a thing. But you give me a tool box. . . .

Joey: All of Flora's drawings are three-dimensional. When she says, "I'll show you my idea," I say, "Okay, I'll be there in a few minutes." When I get there, her idea is hammered up in plywood. That, in a sense, has led to our sculpture.

But, truly, our collaboration works because we are so different. If we weren't working together, neither of us would be making art that would look anything like this. I feel very, very lucky to have literally fallen into a collaboration that I never would have predicted and which has worked out for ten years. I think it is an amazing thing.

Flora: And we're still friends.

facing page:
FRUIT
1990
Blown glass
8" to 30" high

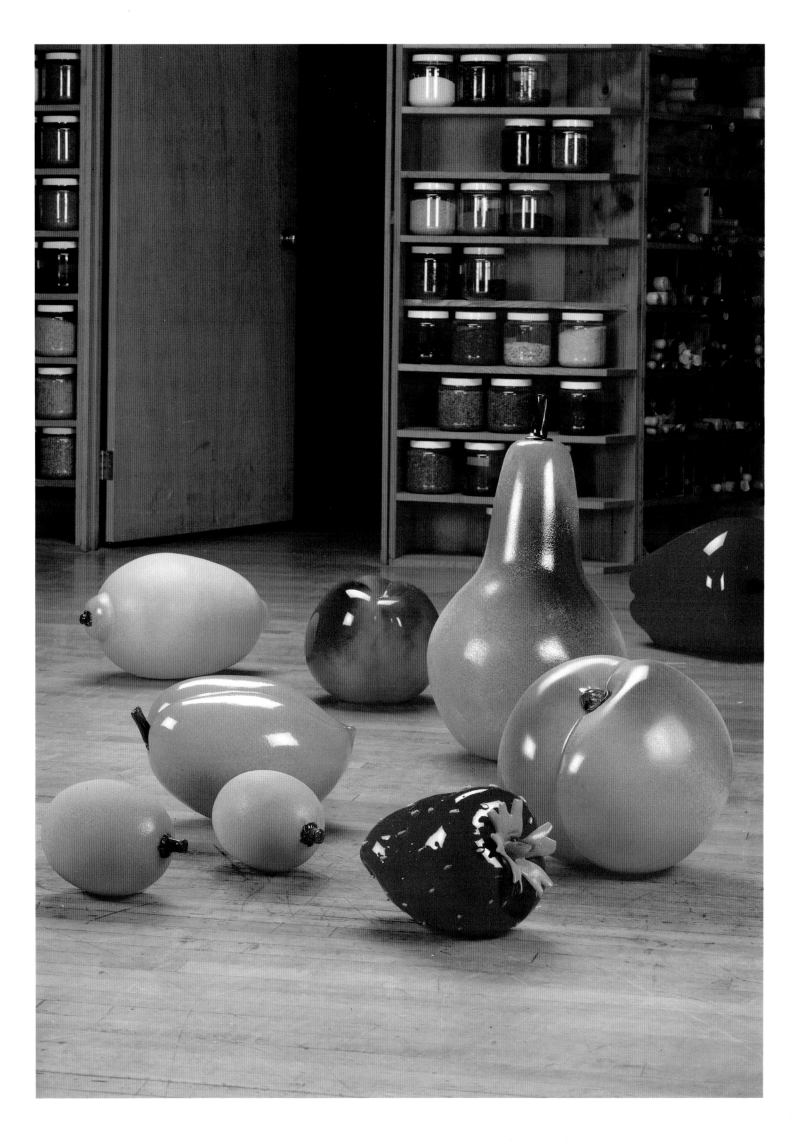

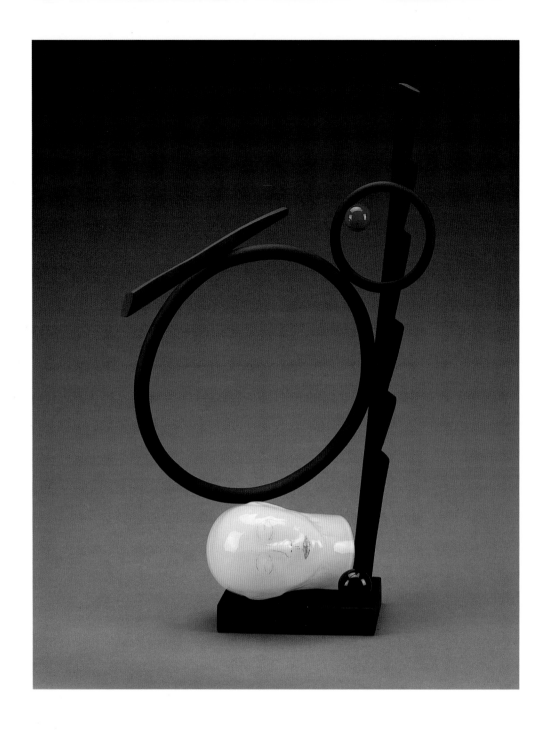

above:

TIDAL MARKER

1985

Glass and wood

37″ × 22″ × 16″

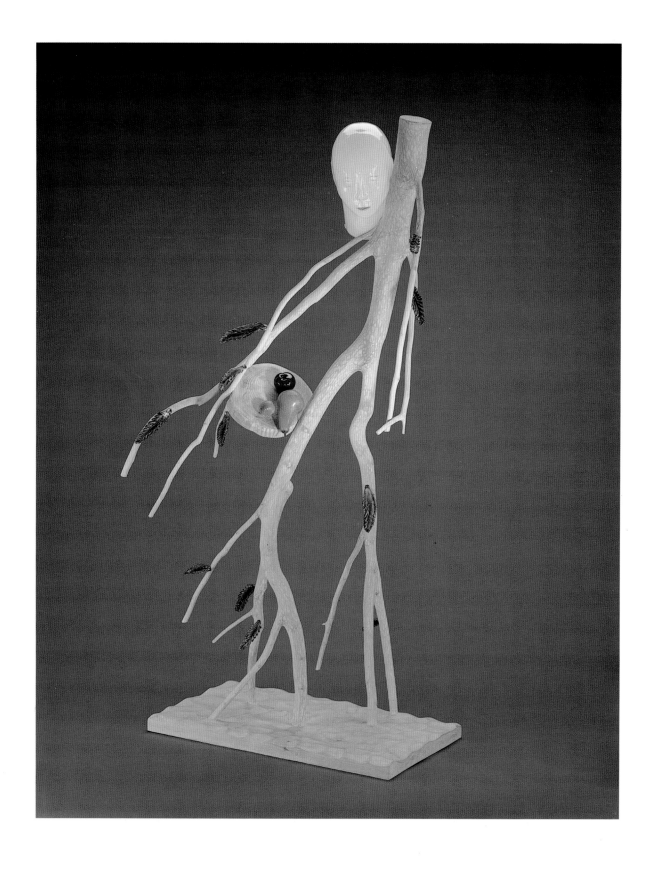

RICHARD LALONDE

In my work and my life, I like to have a harmony, a yin-yang, a balance between the right brain and the left brain. For me, it's important to be both a good craftsperson and an artist. I delight in the technical aspects of the glass. One minute it works, the next it falls on the floor and breaks, or it comes out of the kiln in pieces. So it's like being on the edge of the medium, and I like that aspect a lot. However, I have a large enough technical grasp that I'm free to express what I want to do with the material, especially with the new technique I developed about three years ago with the crushed glass. I lay down the glass, like doing a sand painting, and then fuse it together. This process allows me to blend color and to be much more spontaneous. Drawing with the crushed glass also has permitted me to work more freely, especially in my bowls. I just sit down and make them for sheer joy.

I like to travel, and I want to do more of it. I like to visit places inhabited by people some call primitive, but I describe as "touch-the earth" people, people who live on the ground. They are more sensitive to this planet. They plant their own food, make their own clothes, and live with the symbols of their culture. Our culture has lost that. We're not in tune with the planet. We drive cars and walk on concrete streets. I wonder how many people in the city take dirt in their hands and actually squeeze the earth. What I like to do in my work is bring some of that energy back to our culture. That is one of the reasons I work with bright color. In most touch-the-earth societies like Guatemala, Peru, Turkey, and Mexico, people who live off the land aren't afraid of color. They don't go to art school, and they don't learn the rules of the color wheel, and they don't learn that you shouldn't put this color next to that color. They just do it, and the reason it works is because it comes from the heart. That is what I like to bring to my work: lots of vibrant color from the heart.

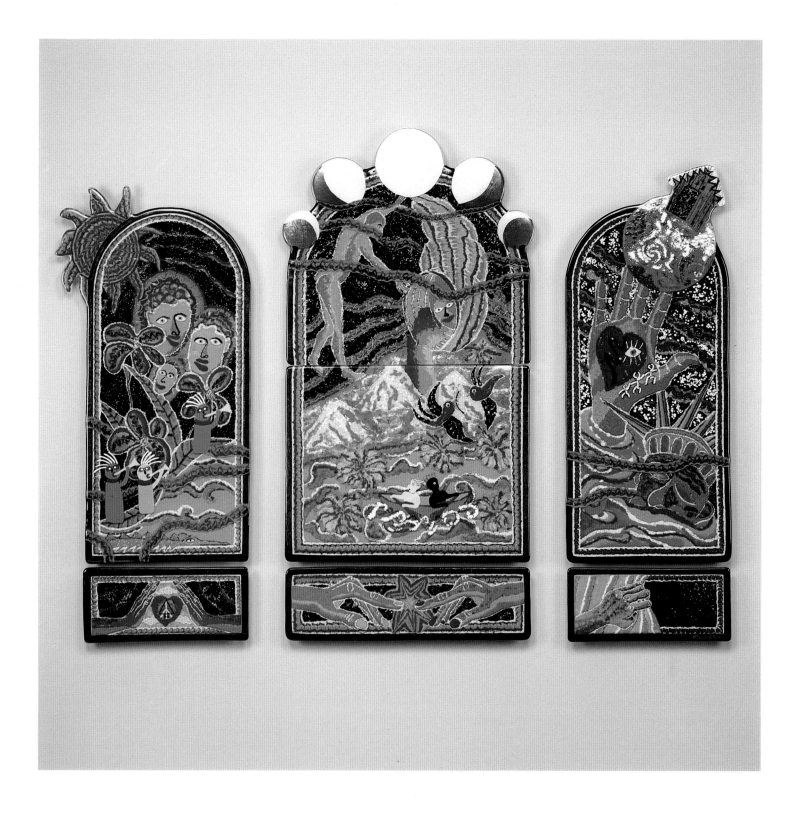

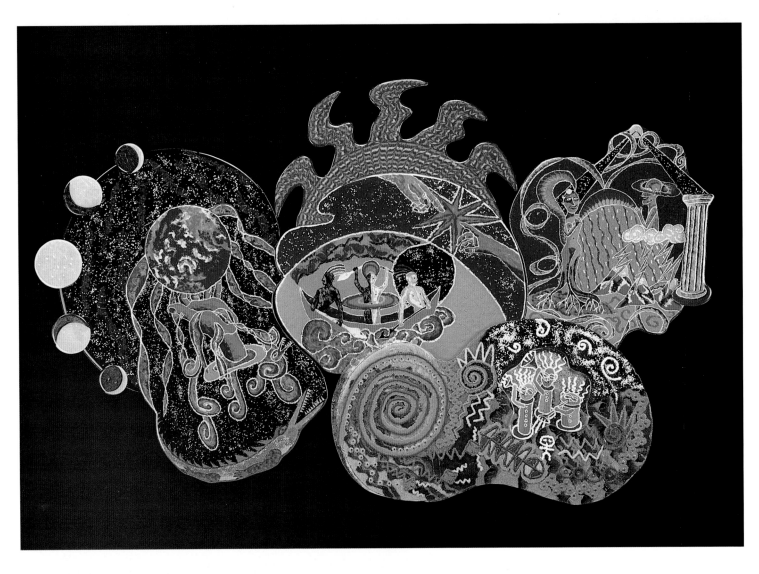

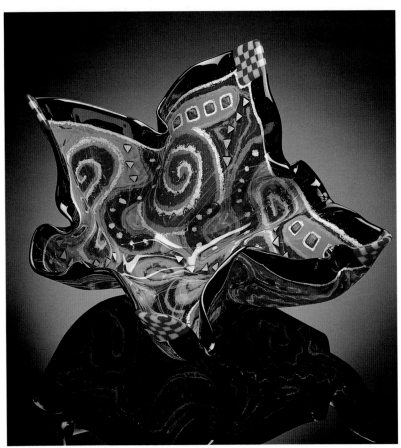

above:

**REMEMBER THERE ARE
STARS IN THE SKY**
1989
Fused crushed glass
with "vitroglyph" technique
48" × 72"

left:

**BOL'ERO WITH RED AND
LIME CHECKERED CORNERS**
1990
Fused crushed glass,
then slumped in metal mold
8" × 15" × 17"

WALTER LIEBERMAN

The best art is something you feel strongly about. If the art has a strong base, it works. I don't think what you love matters as much as how much you love it. Political issues are very important to me, and I hope that because I'm working on something important to me, the depth of my feelings will come out in the work.

I enjoy the dialogue with the paint. Maybe I'll fire something ten or twelve times. At first I sometimes don't like a painting, but as it progresses, it can become more interesting because of the dialogue between me and the image, me and the paint.

I want the work to be a continuing exploration of myself, the world around me, and my feelings. It is a process that grows and develops and changes, and has its highs and lows. The art is really a by-product, the industrial waste. It's not the important part. The process is the important thing, the process of learning, of discovering, of making things, of seeing. The art, in one sense, is a snapshot of that process. It says, "This is how far along I was at that point." It's like taking a slice out of my development, a slice that I hope contains some interesting aspects. A certain degree of fame and recognition is necessary to make a living and besides, without that, people won't value the work. But I don't want to have to curtail my development in order to survive.

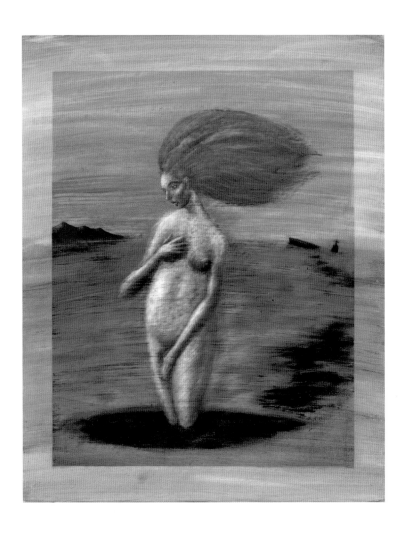

above:

VENUS OF INDIFFERENCE
1990
Enamels fired on glass
26″ × 20″

right:

TIRED OF WAR 2
1988
Enamels fired on blown glass
14″ × 8″

above:

PANDORA'S BOX
1987
Enamels fired on glass
18" × 24" × 6"

DANTE
MARIONI

The physical act of blowing glass is the entire draw for me. The art of glassblowing, the tradition and the technique, is what enticed me in the first place, and it is what interests me now. You start with the rawest of raw materials, a tank full of molten goo, and you must rise to the challenge of making something that you have worked out conceptually. The satisfaction of that is something I can't fully explain.

When I started working in glass at age fifteen, I had no interest in being an artist or a craftsperson. But then I saw Ben Moore work. For the first time, I saw someone make something round, on center, and perfect. In the early 1980s, most people were still making goopy, amorphous things. That's what I learned as a kid, and I couldn't see being an artist doing that. I also saw how much my dad and his friends had to struggle to make a career out of glass, and I had no intention of trying to do that until I saw Ben work and how different glassblowing could be. A year later I saw the Italian glass master Lino Tagliapietra work, and there was no turning back.

I started working glass so young that I never had much time to ponder what I was actually going to be. I had romantic notions of being a major league baseball player or a motorcycle racer, and then one day I was blowing glass. It has never crossed my mind since to do anything else. I don't think Honda or Kawasaki will be calling me up and offering me a contract, and I think the Mariners have their lineup worked out. Besides, I'm very happy. If I were a rich person, I would be making glass because it is fun and satisfying.

facing page:
WHOPPER VASE FORM
1989
Blown glass
25" × 14"

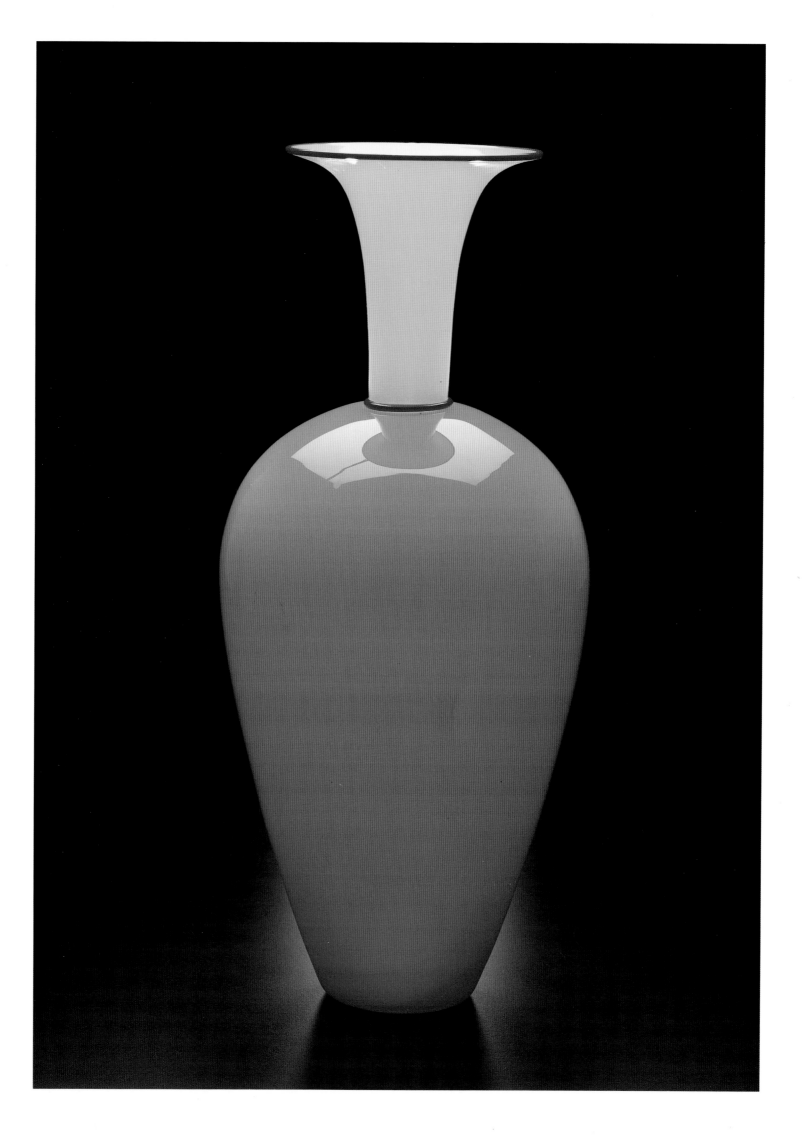

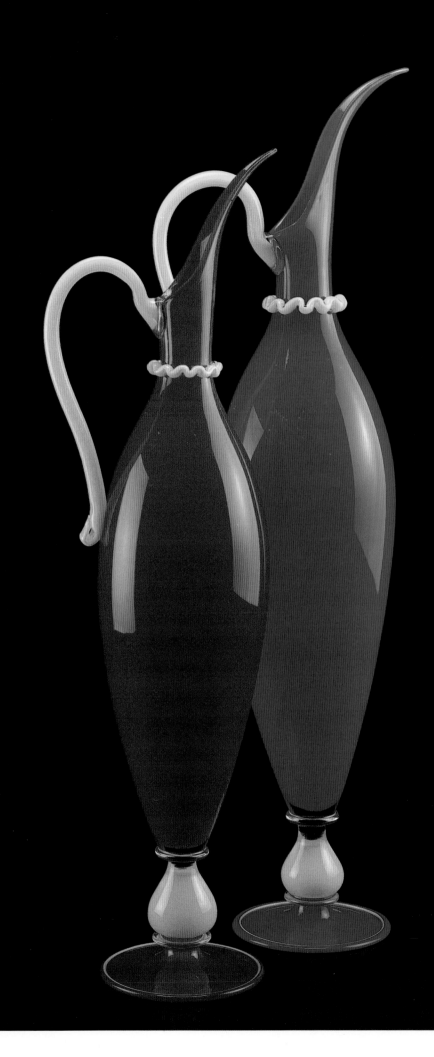

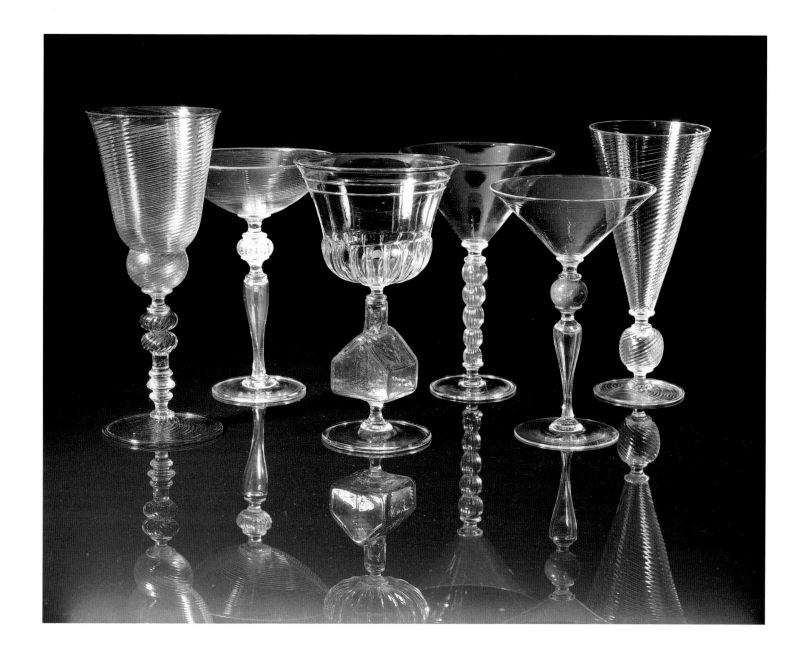

above:

ASSORTED GOBLETS

1988

Blown glass

6" to 8" high

facing page:

GOOSEBEAK PITCHERS

1990

Blown glass

30" × 32" × 11"

PAUL
MARIONI

My work is mostly about human beings, human nature, and human spirit. I have done several political pieces which received a tremendous amount of publicity, far more than they should have. In glass, people tend to make pretty things, and even in the world as a whole, there isn't a lot of political work. So people tend to remember those pieces.

I am not trying to change people's opinions with my work. I just want them to think. When I did *The Premonition*, which alludes to nuclear war, one woman looked at it and said it gave her the creeps. I said, "Isn't it fantastic that a piece of glass, a material which is inherently beautiful and usually conveys a feeling of beauty, could instead give you the willies." She said, "Well, you're right about that, but I don't want to have the willies all my life." It reaffirmed for me that *The Premonition* was a strong piece because it did what it was intended to do. Someone will come along who isn't afraid to have those feelings, and will buy that piece, not because it's about nuclear war, but because that person likes it and sees that the feelings are powerful.

I grew up in the 1950s and was taught to guard my emotions. I think that was a big mistake. Too often, we can't deal with our feelings. Too many people substitute drama for passion in their lives because they don't have the passion. They don't even recognize it when they do have it because they have been taught to hide it. So they have to substitute drama. That's what television does; everything is a melodrama whether it is big or small. And that is what we tend to do in our lives. I am trying to put passion back in my work, to relate to people through passion, because I think human emotions are the universal language.

above:

THE PREMONITION

1981

Stained glass

21" × 27"

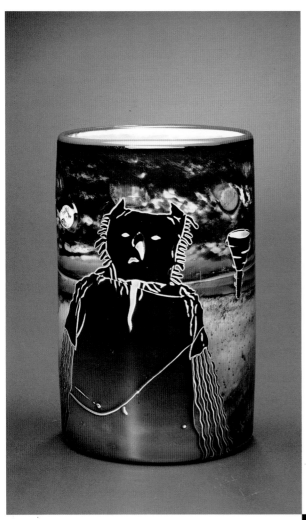

left:
COLD WINTER NIGHT
1990
Blown glass
12" high

below:
SPIDER
1989
Blown glass
11" high

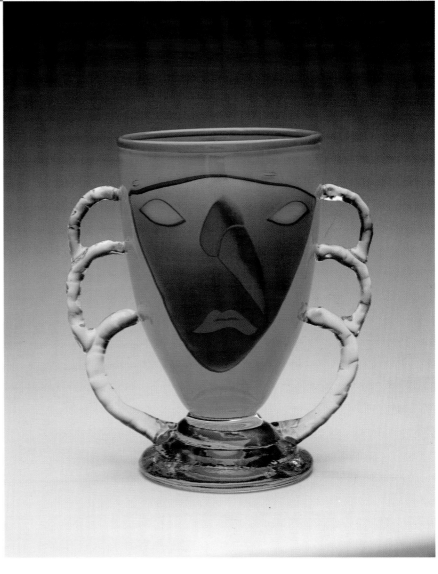

RICHARD MARQUIS

It is important to piss people off. I have a very strong historical background, and I know a lot about glass, but that doesn't mean I hold the material sacred. That is the only way to do something. I think it's important to question the inherent qualities of the material. What could be worse than taking a beautiful *latticinio** object and painting it? I did this little series of work where I made really intricately patterned bottles and spent quite a bit of time on making them really nice. Then, when I was done, I painted them solid colors to get rid of the preciousness. It was like Robert Rauschenberg's erasing a Willem de Kooning drawing. I was trying to say that just because you know how to do something doesn't mean you have to let it control you. I may know how to make something in a beautiful *latticinio* pattern, but that doesn't mean I have to do it.

*Opaque white threads of filigree decoration.

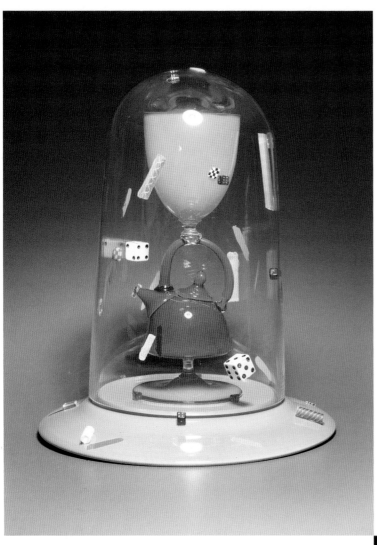

above:

BELL JAR #14

1990

Blown glass, found objects

23" high

right:

GREY ROCK

(LATTICINIO BOTTLE, CELADON VASE)

1986

Blown glass, latticinio technique,

found objects, paint

23" high

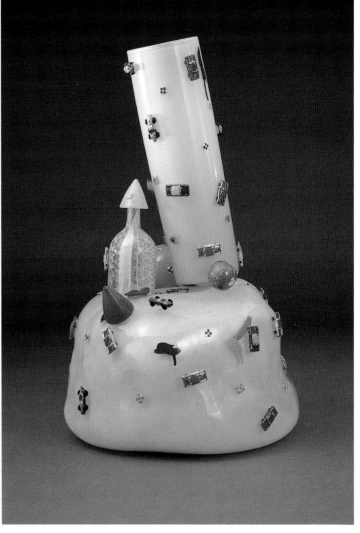

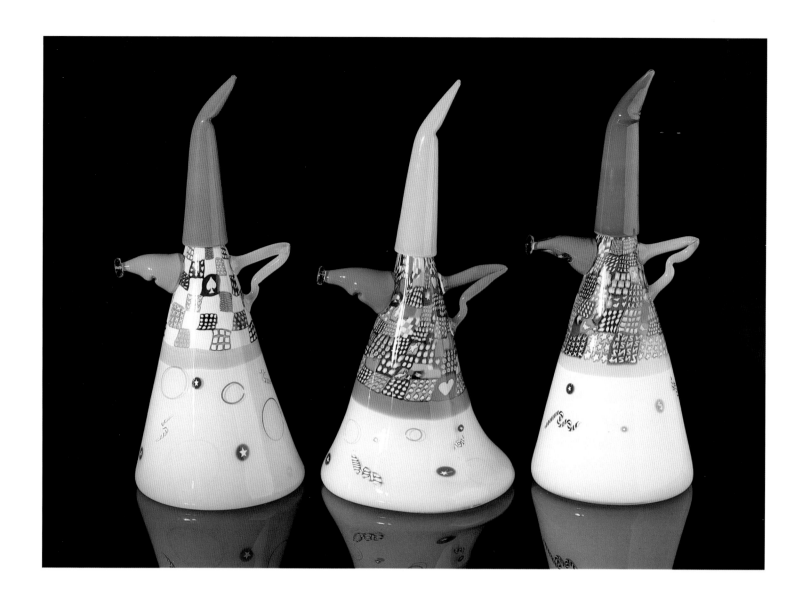

above:

WIZARDS

1985

Blown glass, murrini technique

17" high

NANCY MEE

I am not a "glass" artist. To me glass is *just* a material. Contemporary art encompasses multiple forms and processes and is more than identification with being a sculptor or being a painter. My art embodies certain ideas whether I'm painting or drawing or doing needlepoint. I use whatever form I need to express them. Maybe the reason people like my glass is because I have an irreverence for the material.

When I was in school, I worked in the medical library at the University of Washington. I photocopied medical journals for people. On my breaks, I read the books they brought in and became fascinated with the way medical journalism can condense the most traumatic event in a patient's life into three or four pages, with pictures that are the most brutal documentary. I was particularly caught by the images of scoliosis, a spinal deformity, and the bracing that was used to correct it. The braces looked like objects of torture, but were actually objects of healing or helping.

When you see a quadriplegic in an arm brace, you might think, "Oh, how tortuous that must be," but it actually allows that person to use the one muscle that is still functional in his arm, to still have use of a hand. Seeing an amputee's artificial leg, we might say "Oh, that is awful!" but it allows the person to walk. I loved the duality of that and also how the images in the books were used as an information tool. Those images conveyed so much and they are still so poignant to me.

This was a jumping-off point for me. People think that I am interested in scoliosis, but I'm not. I am fascinated with deformity, the shock of being different, and the darker side, and how society and culture mask those. I'm fascinated with my role as an artist, the vision I have to share, and my role as voyeur. We are all different, and we all have our dark sides, and I am just fascinated by it all, beyond the physical aspects.

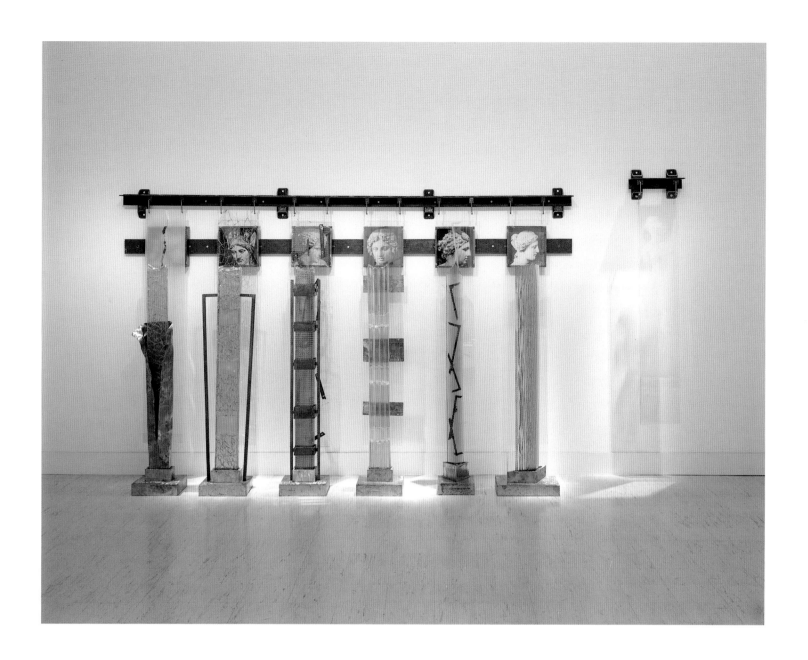

above:

SEVEN BEAUTIES

1987
Glass, steel, copper,
photo sandblasted on
glass, brass, photo
84″ × 156″ × 16″

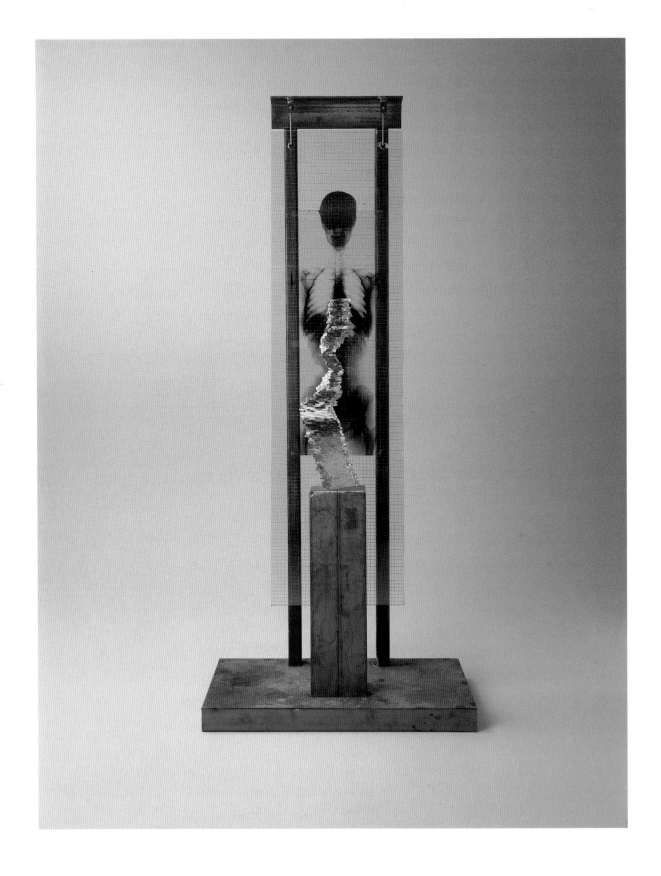

above:

BODY STUDY

1989

Glass, steel, diazo

86" × 38" × 21"

below:

ENCASED IN THEIR BELIEFS

1990

Glass, steel, wood,

forged steel, photo

sandblasted on glass

80″ × 38″ × 22″

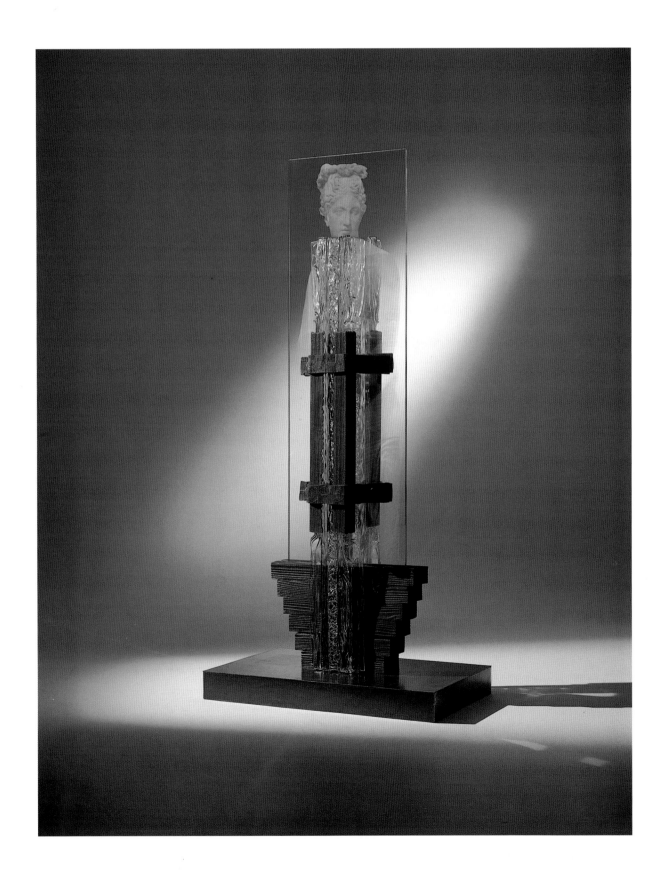

BENJAMIN MOORE

I have always liked beautifully designed, decorative objects, and the fact that I made a move in my work from table objects to lights seemed a very logical progression. The glass lends itself to both. The floor lamps are one-of-a-kind pieces. I think of them as sculptural objects. The bases are exquisitely handcrafted out of bronze by Louis Mueller. But the lamps fall into a kind of no-man's-land with the galleries. Because they are unique and collaborative, the lamps are often too expensive to do well in design galleries. Even though they are sculptural objects, the fact that there is a piece of glass on top and a light bulb inside gets them turned away from art galleries. So it poses a dilemma.

I love the process of blowing glass, of working with the medium. I like to work hard. I like to sweat. I like the speed, the challenge, the centered feeling I get from working on round. I'm not interested in the organic mode of glass. I like the forms to be clean, round, even. I can appreciate the opposite, but it's not me. Because I am most interested in simple and subtle forms, many people miss what I'm trying to say. They look at the work and think it is a piece of factory glass made by a machine. But I want to work with the material the way I work with it rather than try to be organic just for the sake of being organic.

facing page:

THREE FLOOR LAMPS

1990

Blown glass shades, Benjamin Moore;
Hand fabricated bronze bases, Louis Mueller
80″ × 11″

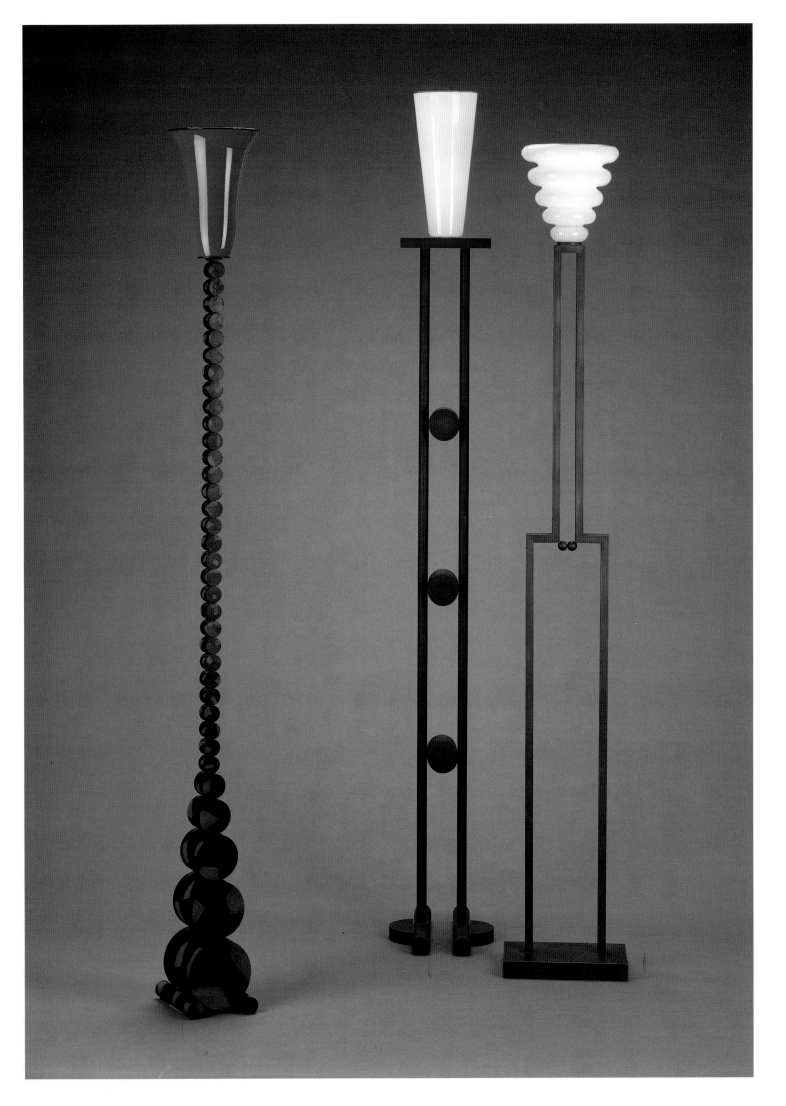

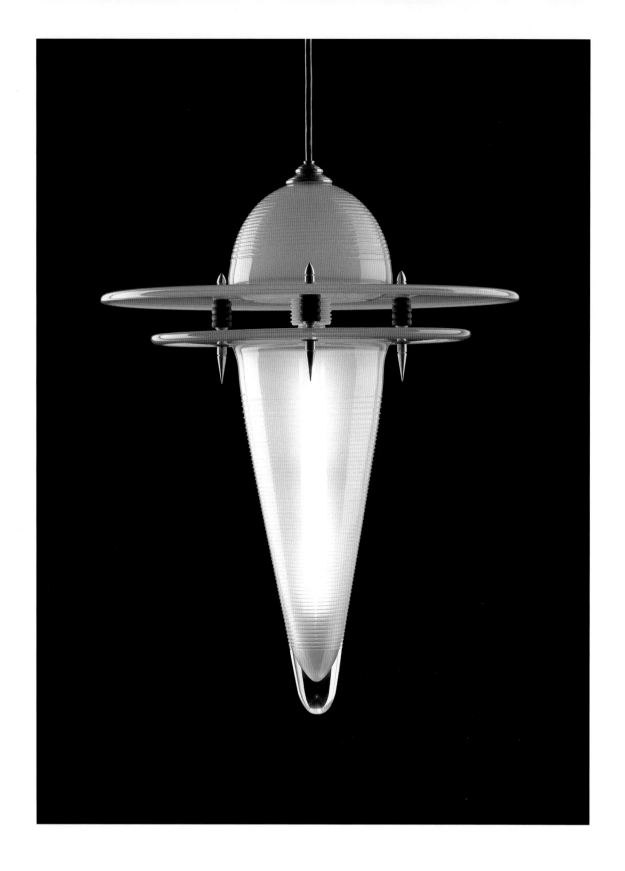

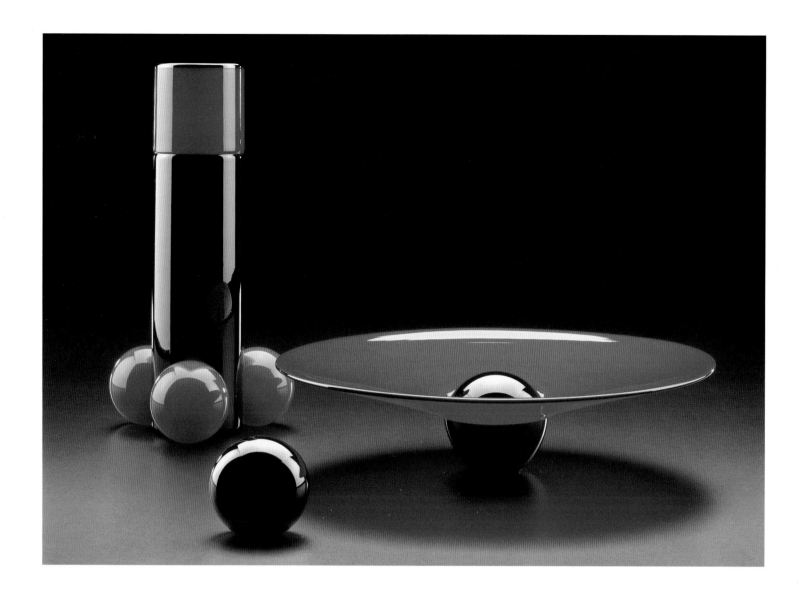

above:

PALLA SERIES
1989
Blown glass
21" high, 21" wide

facing page:

HORNET LAMP
1988
Blown glass with clear wrap, Benjamin Moore;
Metal fittings and assembly, Walter White
18" × 16"

WILLIAM MORRIS

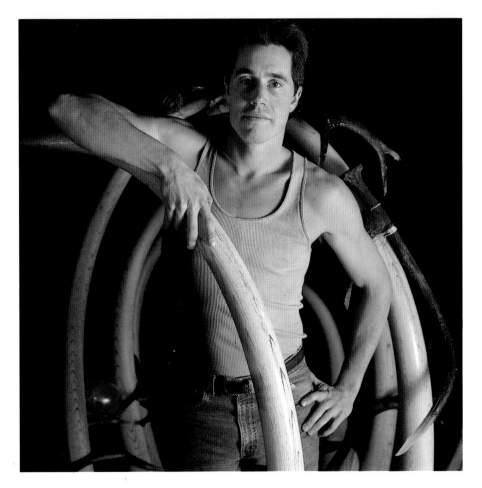

There are certain things that have always interested me. When I was growing up in Carmel, California, we found Native American burial sites and picked up artifacts and relics. It was a fantastic area. I also remember going through the Sierra Mountains and finding arrowheads, and this and that. I've always been interested in these sites, but not as a collector. I would rather see the objects in their settings and wonder about how they were created and why they came to be. What transpired? What was the motivation of the people who built the site? But I don't care about scientific theories, the *science* of archaeology; I like the mystery and the romance of it. I like the fresh, spontaneous ideas that people have when they respond to what is there.

That response in myself was what started me on the first series, the stone vessels. I am not trying to replicate anything that I have seen but, rather, to create objects that I would like to find. For instance, to me, the symbols in the skulls suggest what you'd be able to see if a person's lyrical ideas could be preserved along with his or her remnants. I love the idea of that possibility. I want my work to be suggestive rather than definitive, and the stories to be open-ended, so I try to arrange the bones so there is more than one possibility for people to read into them.

I don't think of bones as meaning death or morbidity. I think that bones and relics emulate life as much as the flesh does, because they can define a situation for eternity, whereas the flesh lasts only for an instant.

facing page :

BURIAL URN
1990
Blown glass
34" × 20" × 11½"

78

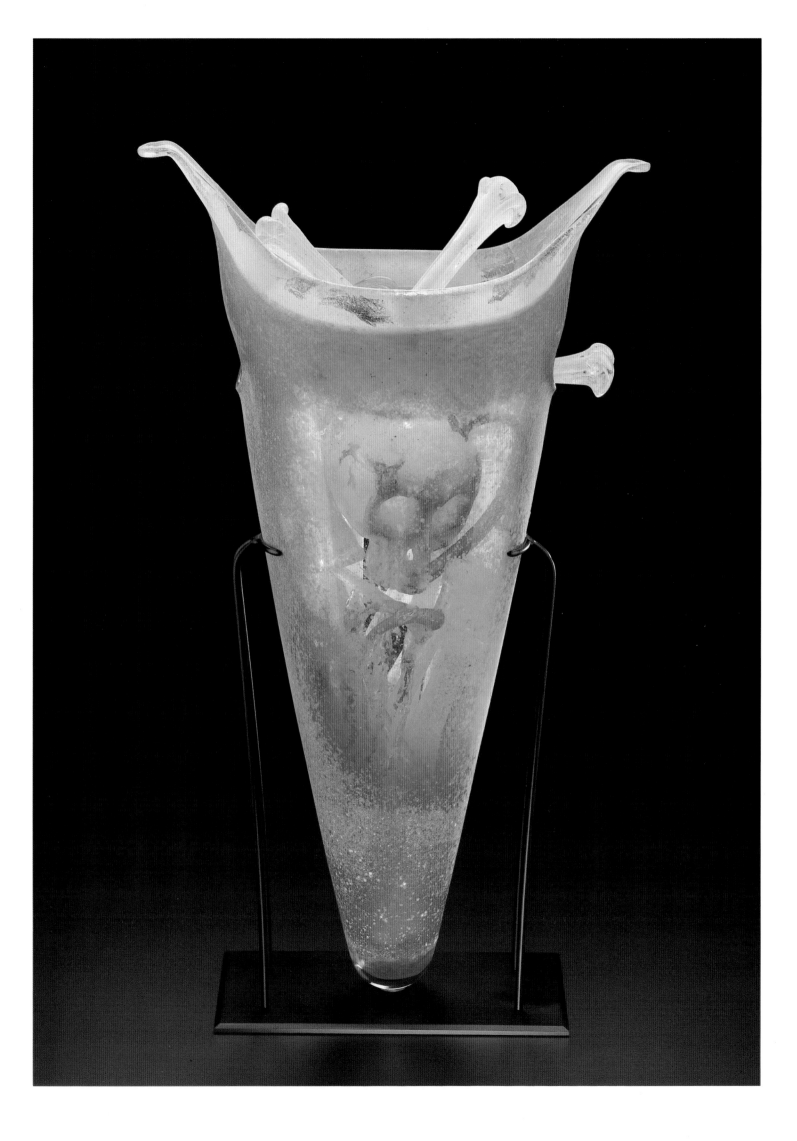

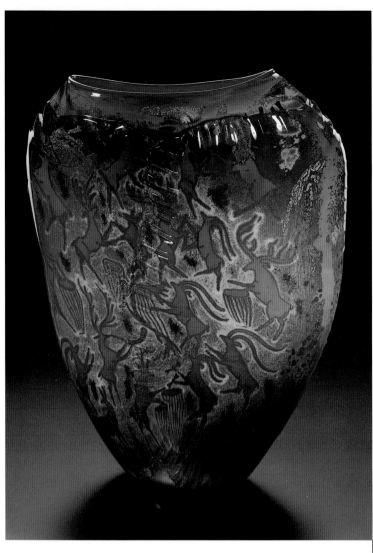

above:

PETROGLYPH VESSEL
1990
Blown glass
26" × 20" × 7"

right:

ARTIFACT STILL LIFE
1990
Blown glass
21" × 20" × 20"

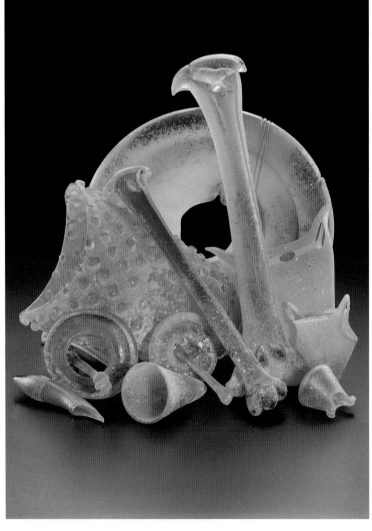

CHARLES PARRIOTT

When I was sixteen, I was living in California, and I spent a lot of time on the beaches. I started twisting horns out of sea kelp and drying them in different configurations. The next year, 1970, I ran into Tom Patti, who had been a graduate student of my father's in industrial design at Pratt Institute. I asked him what material I could use for these horns because they took a long time to dry, they smelled bad, and if it rained, I was ruined. He said that glass would take the form very easily and wasn't hard to learn, so I decided to go to the California College of Arts and Crafts to try it. I became enamored of glass at CCAC. It felt very natural to me. In addition, the glass scene was livelier than any situation I had ever participated in, and was very attractive to me.

In 1985, I was awarded an International Research Exchange Board grant to study with Stanislav Libensky and his wife Jaroslava Brychtova in Czechoslovakia. From them I learned a more classical approach to working in glass. They taught me that since I was spending so much time working on a sculpture, then I should enjoy drawing it again and again. I found out that drawing a sculpture wasn't just some sort of one-time, mental ejaculation. By going through it repeatedly, I could discover why I wanted to make it, what was interesting about it, and what excited me about it. All this seems basic, but in the 1970s, American glass artists just didn't have the same attitude. We thought that experimenting and expressing freedom in our artwork were more important than the art itself.

I want my work to be simple and beautiful to make. I care less what other people think of the work than that it has its own beauty. Whether the beauty is grotesque or sentimental is not the issue. It just has to have something for me.

below:

HUNGRY BEAR

1990

Blown glass

16″ × 18″ × 10″

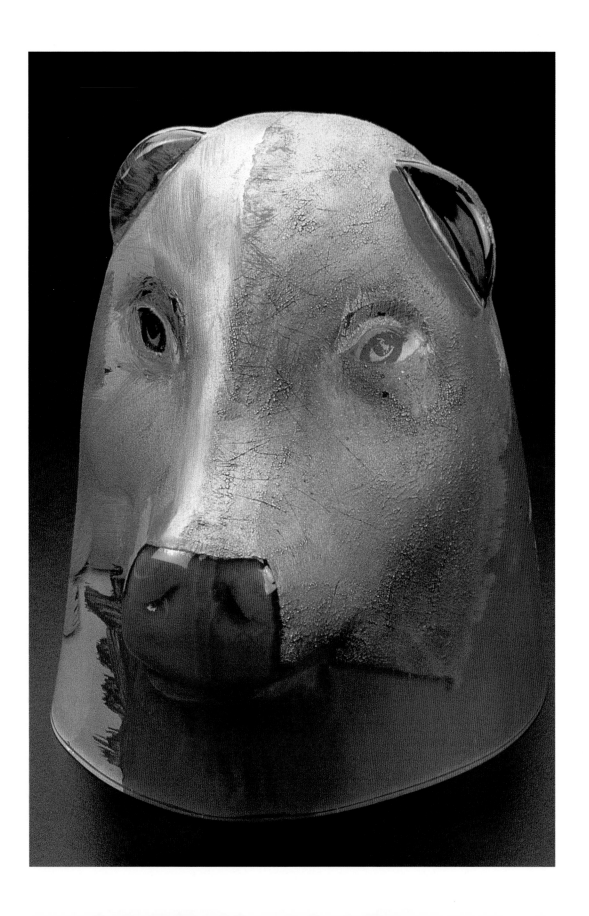

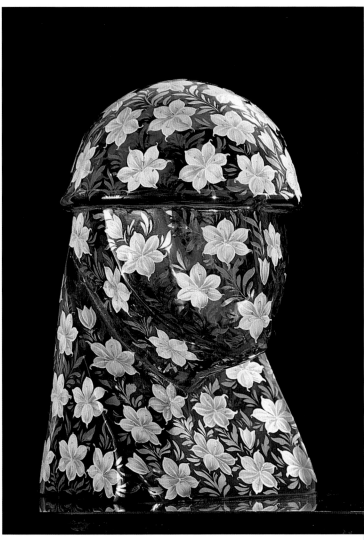

left:

FLOWERED SOLDIER

1990

Blown glass

Painted by Zdena Koliova

14″ × 9″ × 9″

below:

MEESHA

1987

Blown glass

12.3″ × 9″ × 10″

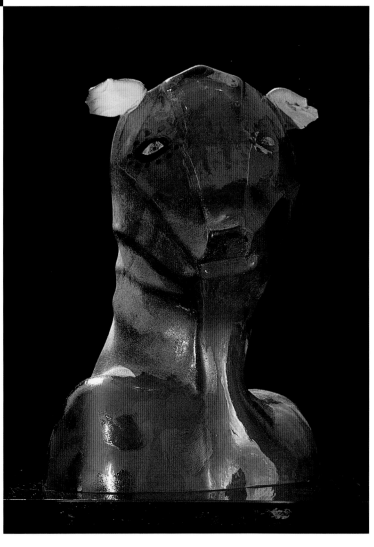

DANNY PERKINS

I started working with broken vases when I was still doing production work in California. When you are blowing glass, if you drop it or it has a little crack, it is thrown away. But the way I saw these pieces started to change, and they became valuable to me. Few people supported me at first. In the craft world, breaking glass, painting it, and putting it back together are all wrong things to do. If the glass is broken, it is garbage; if it is painted, it is more than glass and has lost its purity. Within a couple of years, however, I was having enough shows and selling enough work that I was able to open my own studio.

When I start working, I seek to make an ultimate expression of my emotional state. I experiment with shape all the time. A body of work is an exercise until I'm done. I always have to do a group of pieces—I can't do just one. When I am half finished with one piece, I am thinking of the next. Often I have three pieces going at once. By the time I get to the last pieces, I am able to resolve some of the earlier ones and tighten them up. A piece is never really done until it is out the door.

I like the beauty of color and form, and the organic sense of the work, which to me means growth. By combining these qualities, I get hope that there is some sort of connection with me and the universe.

facing page:

RED WITH GREEN

1990

Blown glass, oil paint

48" × 17" × 14"

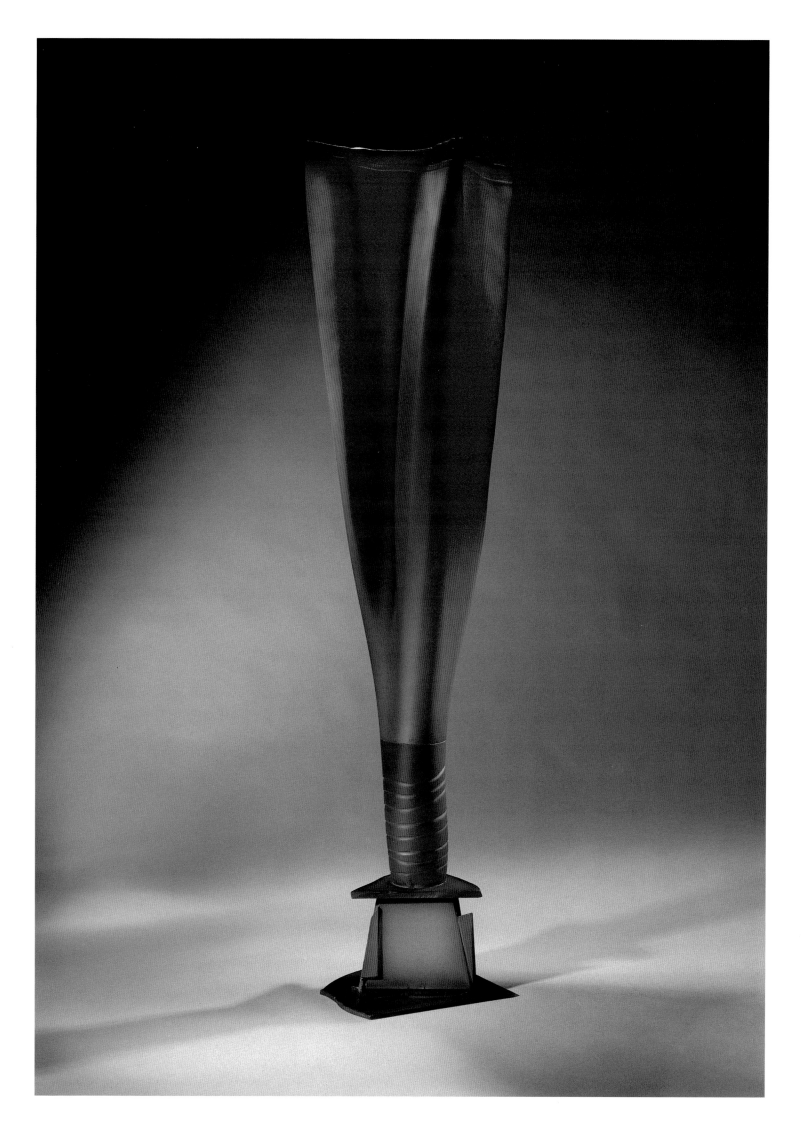

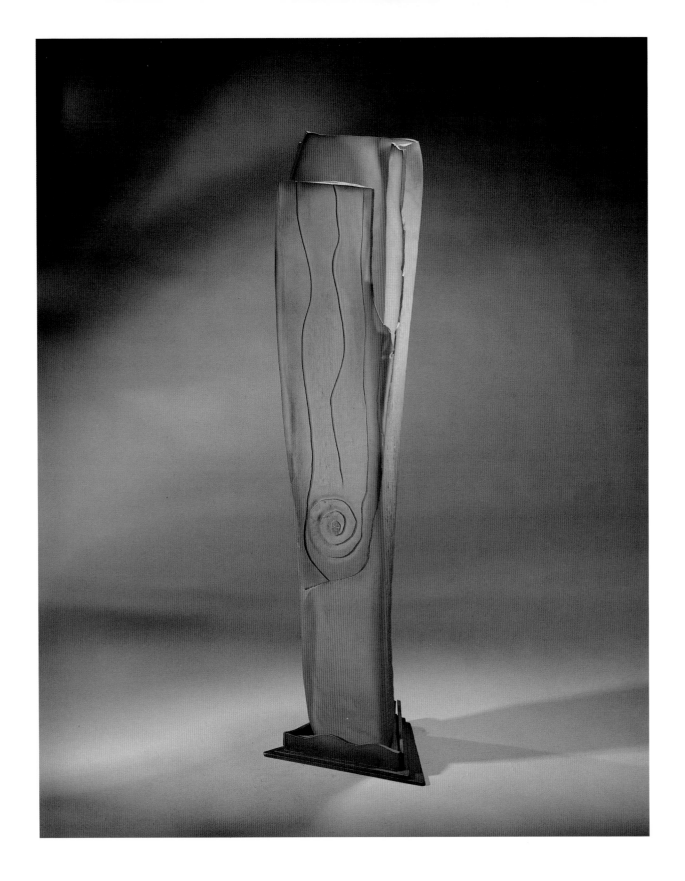

above:

GREEN WITH YELLOW DOT

1990

Blown glass, oil paint

33″ × 11″ × 11″

below:

YELLOW RIB
1990
Blown glass, oil paint
48″ × 11″ × 11″

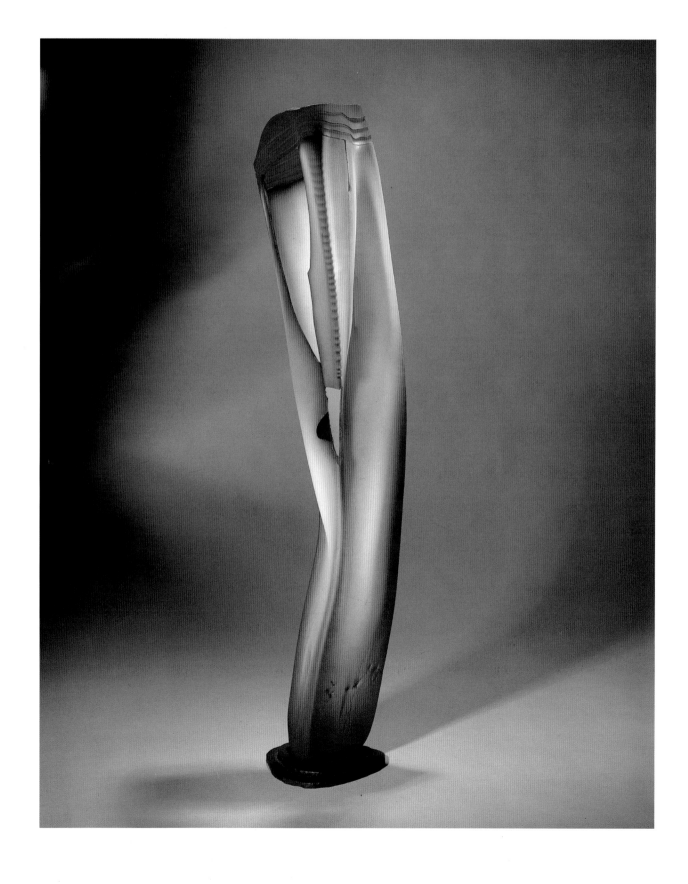

SUSAN PLUM

I originally saw my pieces as somewhat ceremonial and ritualistic. Now I am working from a wider perspective, thinking of them in terms of radiating energy, and of evolution on both an inner and an outer level. I don't use symbols separated from the whole. For me, the body of work creates the symbology.

I think the element of ritual is certainly important in my later work, but now ritual has more to do with the presence of the piece. I look at ritual as being a participatory experience. These are conversation pieces. You go up and have a dialogue with them. That is a ritual in itself. I think of that dialogue with others when I am making the piece. I am not just trying to say something about myself, but am relating to other people's experiences and perceptions as well.

Each material in the piece has its own quality. Glass translates energy and light. I choose other materials by asking what will best interpret the shape I am working with as well as how a material plays into the entire piece. There is an alchemy that happens in combining materials because of the language spoken between the glass and the metal, the glass and the cement.

facing page:

FA: INSTRUMENTO DE ORDEN
1990
Lampworked glass, metal,
porcelain enamel, cement
53" × 15" × 12"

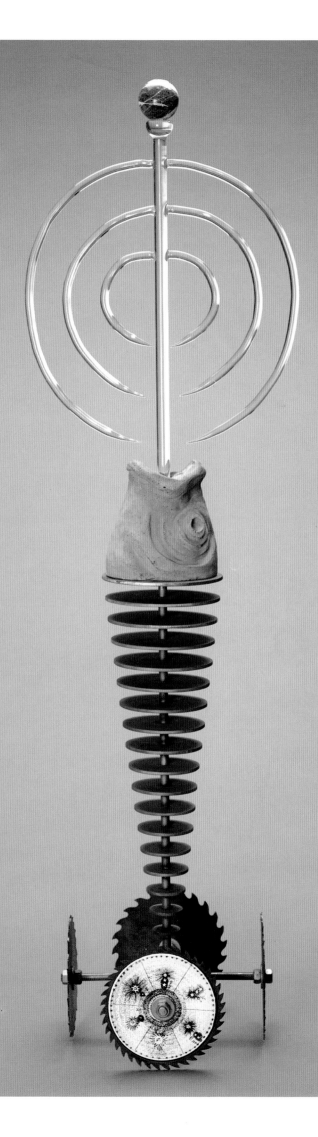

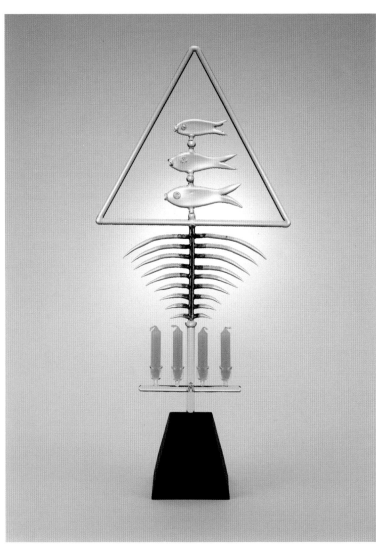

left:

RETABLO: PESCADOS

1990

Lampworked glass,
fired lusters, wood

42" × 17" × 8"

below:

RE: EVOLUCION LUNAR

1990

Lampworked and blown glass,
metal, porcelain enamel

51" × 26" × 7"

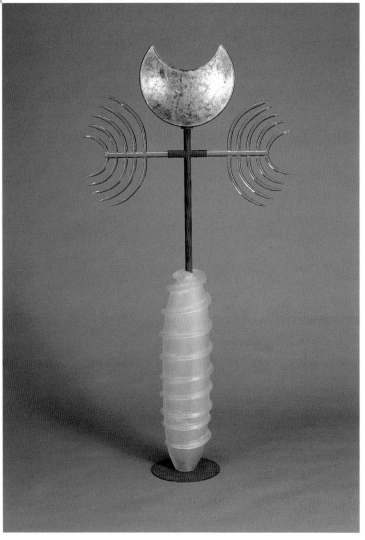

AMY ROBERTS

Contrast has been a theme in all my work. In my early work the contrast was more emotional, between things that looked as if they might topple versus things that looked very secure and powerful. Now I am working toward pure visual contrast, for instance, between the formality of plate glass in a cube and the rawness and randomness of a bundle of sticks.

I am also concerned with integrity and loss of integrity, and with problems and their resolution. Part of the reason I work with glass is because of its connotations of preciousness, beauty, and glamour. But these are only valuable to me because I can negate them, and then, in turn, can resolve the conflict that develops.

I could never work with glass just to make it more and more beautiful. It wouldn't serve any purpose to me. So I work with shards, or if I blow a piece, I get out a torch and cut holes in it. I do anything that defies the integrity of the glass. I don't want to destroy it, to make an ugly piece, but I want to make a piece that has tension in it. Ugliness isn't very interesting if it is pervasive throughout a piece. It's only interesting when it is paired with beauty. That sets up the dynamics on which I thrive.

In this new work it is important that I don't try to make it pretty or disguise the material. If I use wood, I don't paint it. If I use concrete, I let it be concrete. I trust my own vision enough that there is no need to cover up anything. I want the work to have power and to be connected to my own gut response to it. I work more intuitively than I did before. I'm looking for an idea that is powerful, directed, and honest, and reveals my thoughts, my commitment, and my sensitivity—work that exposes more of me.

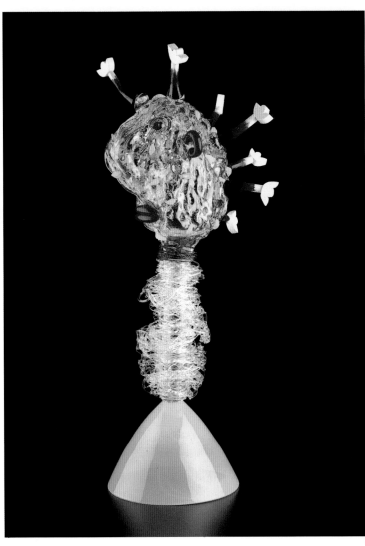

left:

MAN WITH POX

1990

Mold blown glass with

color applications,

spun glass components,

baling wire and enamel

38" × 18" × 16"

right:

SPIRAL HEAD

1990

Blown glass with twisted spiral,

fabricated components

42" × 18" × 18"

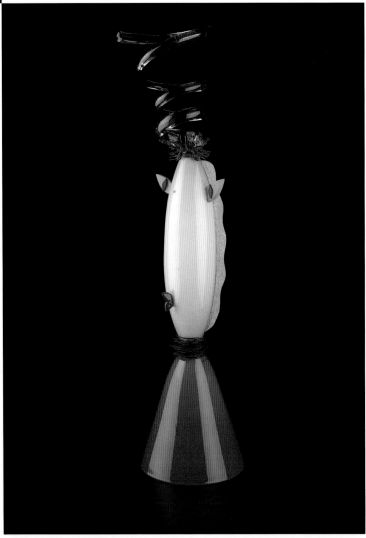

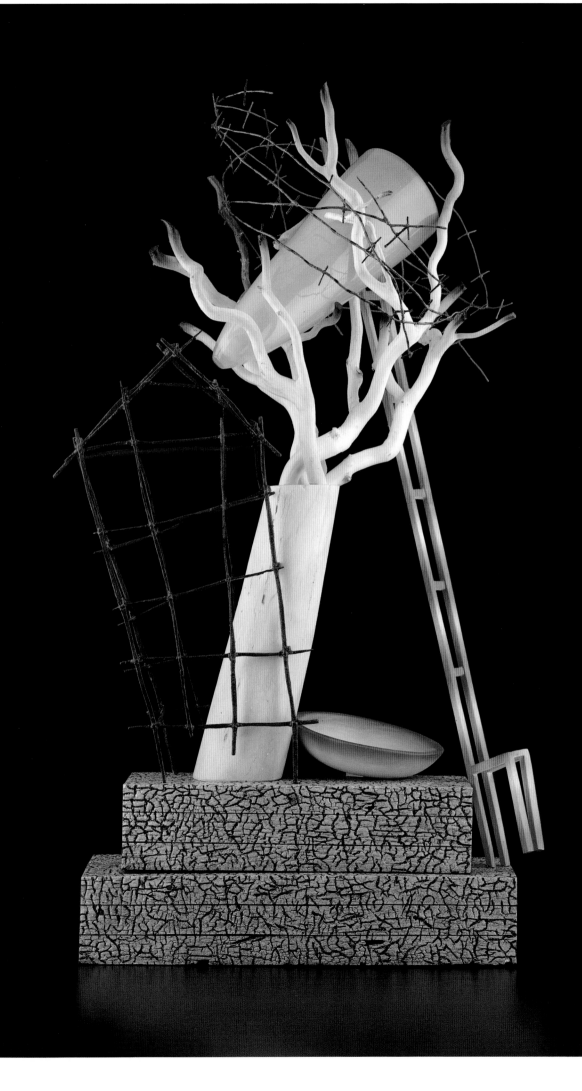

RICHARD ROYAL

What I like about glass is that it is a molten material, a liquid whose movement is distinct from anything else. I try to incorporate that fluidity into my work. When you are learning to work glass, you try to control it, but it controls you. It is hard to coordinate your hands so they respond to what the glass is doing. The glass is just so foreign, unlike any material you've ever handled, and it's a big battle. But I have worked with glass long enough that I have reached a compromise with it: I allow it to do what it does best, and it still allows me a certain amount of control over the final form. I hope there is a collaboration between myself and the material.

I spent a lot of time in my early years trying to get each piece perfectly on center and made very symmetrical objects, but they bored me after a while. Much of my work relies on a great deal of heat, gravity, and centrifugal force to develop the final form, and unless the pieces are on center, I can't heat them really hot in order to make them flow and move the way I want. Although I still rely on symmetry during the process, I'm much more interested in an asymmetrical form for the finished product.

Almost all my current pieces have vertical lines. They seem to be reaching up, as if exploding off their bases. They express what I like to call the vertical nature of faith, especially the *Shelter* series. The pieces are ascending spirals that appear to expand and grow. It's not in my nature to change quickly, so they remind me to accept growth and change, and to believe that things can keep getting better.

facing page:
SHELTER SERIES "INTERLOCK #137"
1990
Blown, fused, and hot worked glass
17" × 40" × 12"

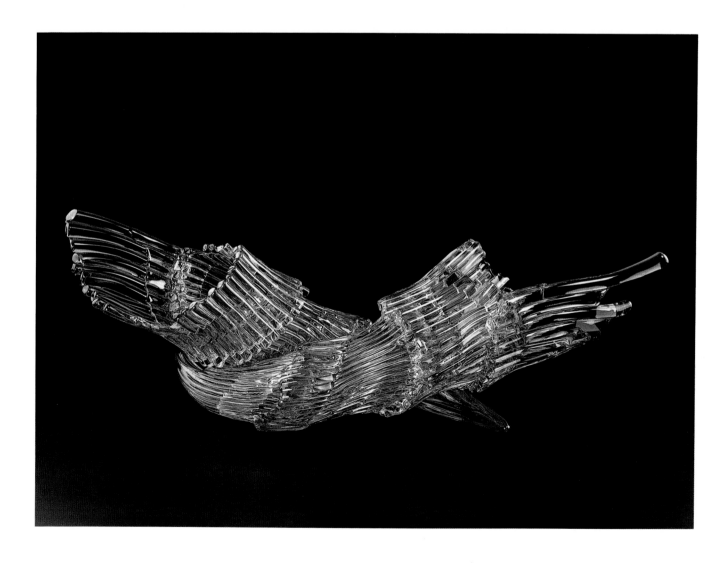

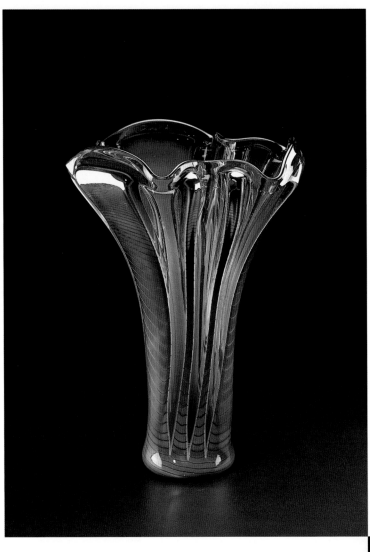

above:

DIAMOND CUT SERIES—UNTITLED

1990

Blown glass

23″ × 17″ × 15″

right:

DIAMOND CUT SERIES—UNTITLED #140

1990

Blown glass

25″ × 18″ × 15″

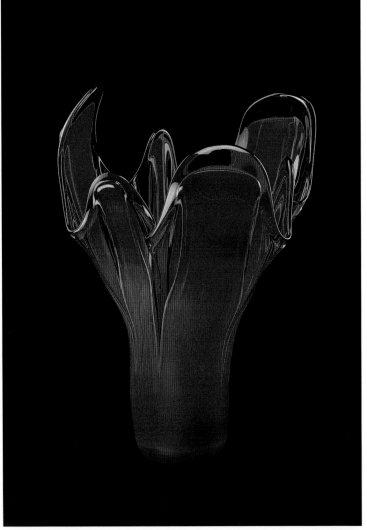

BRYAN RUBINO

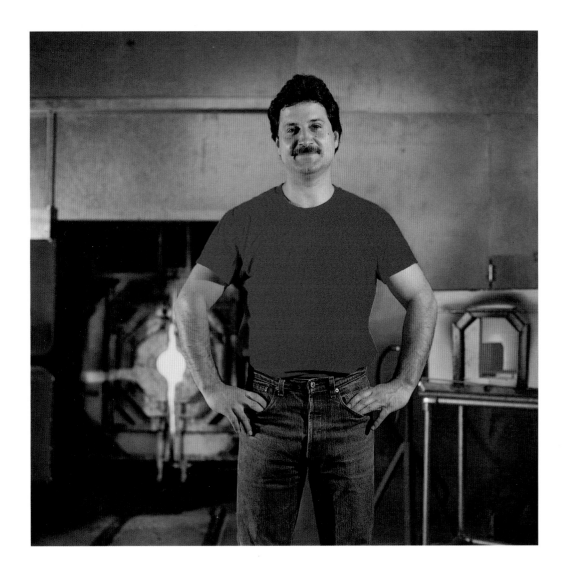

I am trying to get as good as I can. I want to be so versatile that I can do anything. Making money doesn't matter to me at all. I'm just interested in blowing glass. That's all I really love to do. Of course I am happy when a piece is sold and when people appreciate the work, because the pieces are hard to make. The stemmed bowls, the tazzas, each take maybe an hour and a half to do. But once I make a piece that comes out well, it just makes me want to do another one.

The techniques for doing the traditional work are what intrigue me. I don't consider myself an artist. I am a craftsman. For me right now, what matters most is assembling these pieces in a way that is as close to traditional Italian work as possible. But in the process of doing that, I will create a body of work that is my own.

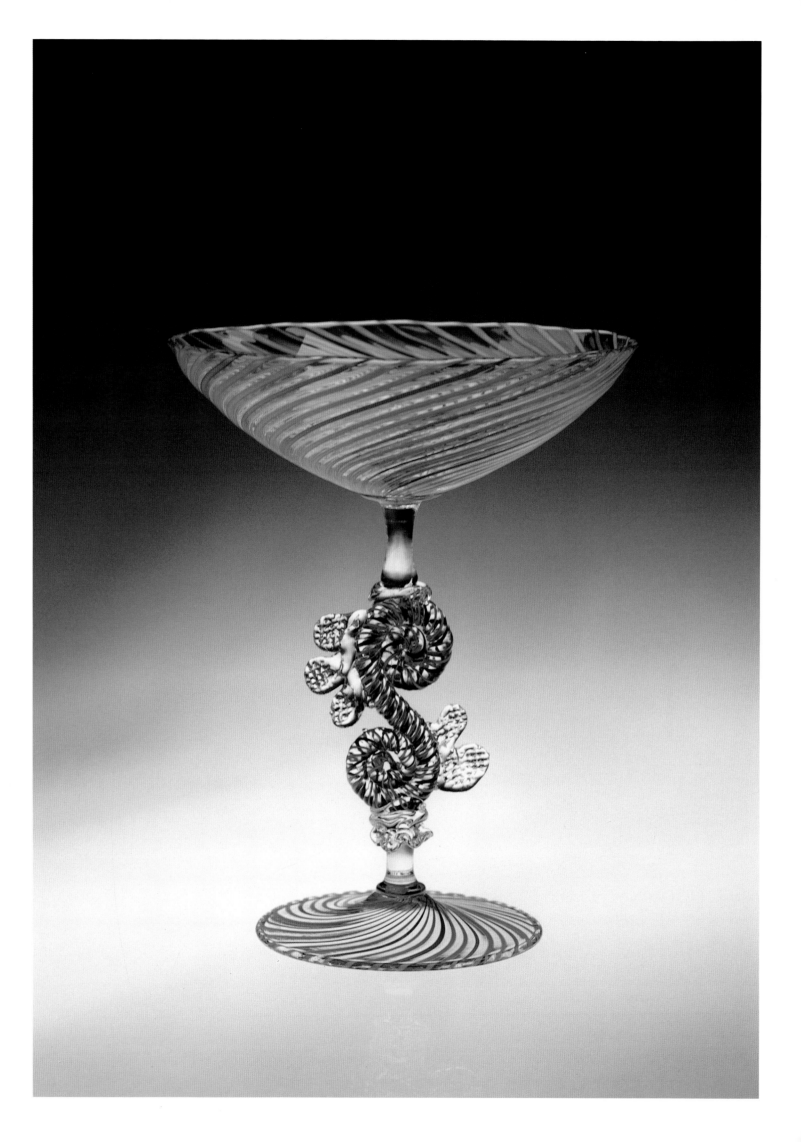

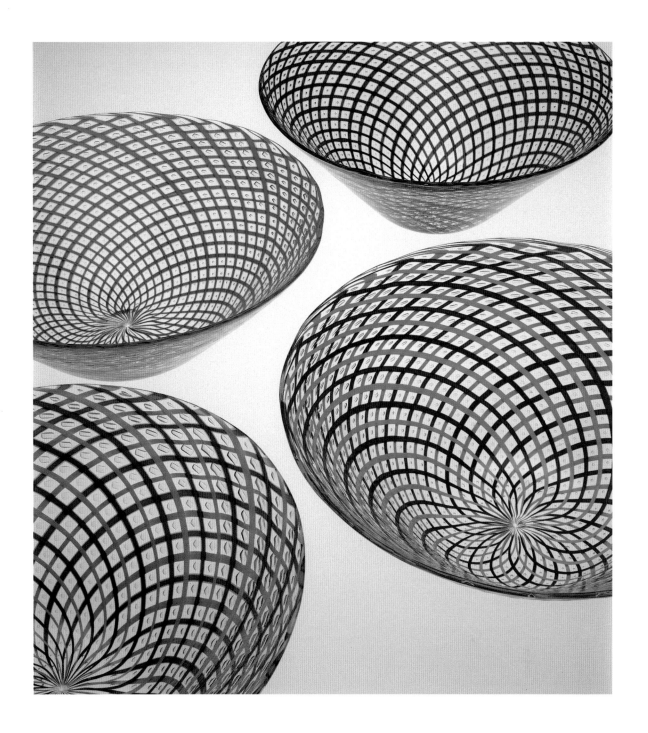

above:

RETTICELLO BOWLS

1990

Blown glass

3″ × 8½″

facing page:

SERPENTINE CHAMPAGNE

1990

Blown glass

6½″ × 5½″

GINNY RUFFNER

I started painting on glass in December of 1984, while I still lived in Atlanta. At the time, I was doing very large, colorful paintings and making relatively small, pristine glass sculptures. I decided to synthesize the two. Soon the glass forms became more elaborate, and in November of 1985, right after I moved to Seattle, I began work on the first narrative pieces.

I paint the glass sculptures with acrylic, urethane, oil, dye, colored pencil, enamels—anything that will work. With this method, I can layer pastel over watercolor and get not only a beautiful and different color, but a different transparency. There are layers of paint, layers of imagery, and, I hope, layers of meaning.

Whatever is occurring in my life at the moment gets into my work: architecture, affairs of the heart, questions about natural and cultural phenomena, beauty—what that means for an artist and a woman—and also morals—what is right and wrong, and what that means for me. For me, the only sin is wasting myself, rather than stretching or testing myself. The things I like are those that give me an opportunity to fill in the blanks, to connect the dots, to participate in the storytelling.

Absurdity, irony, and humor play major roles in my art because I don't think you can go through life as an intelligent person and not think it is absolutely hysterical. Life is too short not to enjoy every minute of it. I find almost everything humorous, even those things that superficially are not so, and they are often ironical. Some people wonder how I can make work that is happy when there is so much misery in the world, but that's the very reason why it is necessary to make ebullient and celebratory work. I could beat people over the head with the awfulness of day-to-day reality, but life itself already does that. My role as an artist is to show an alternative.

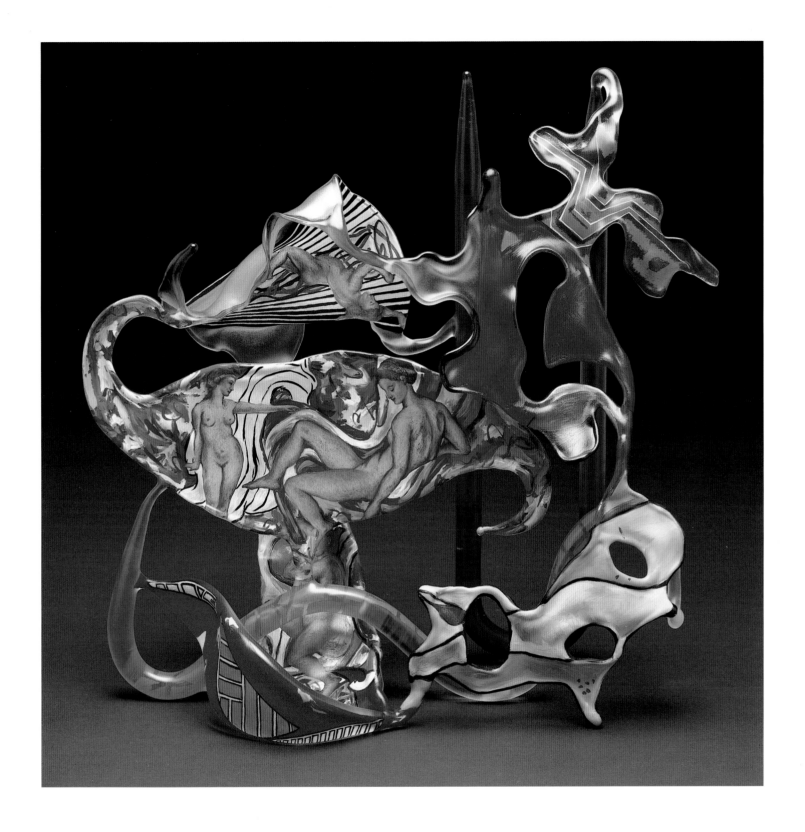

above:

STELLA AT THE LOUVRE

1990

Lampworked glass and mixed media

17" × 16" × 9"

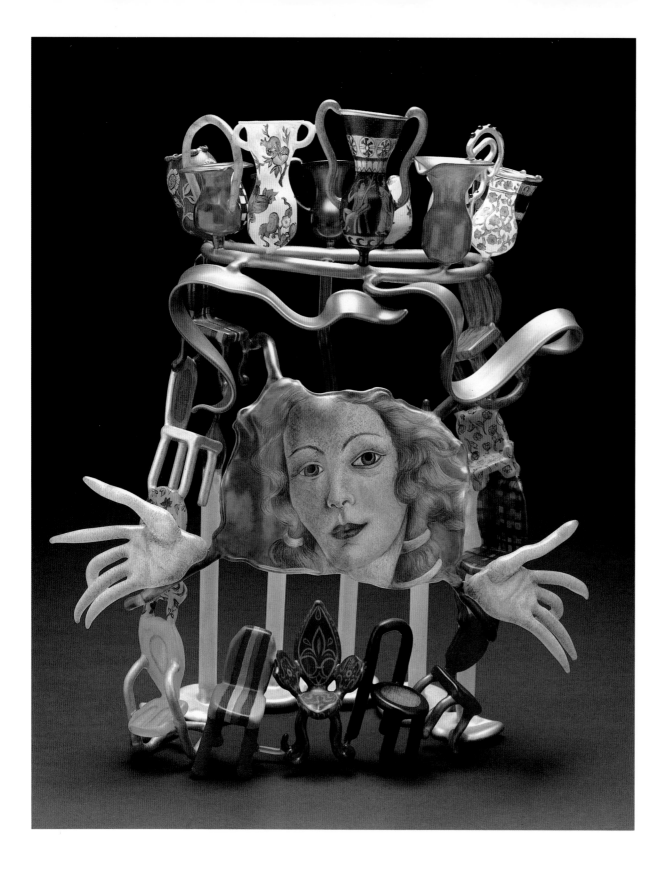

above:

LA DONNA MOBILI

1990

Lampworked glass and mixed media

24" × 21" × 15"

below:

BEAUTY AS IDEAS

1990

Lampworked glass and mixed media

19″ × 18″ × 20″

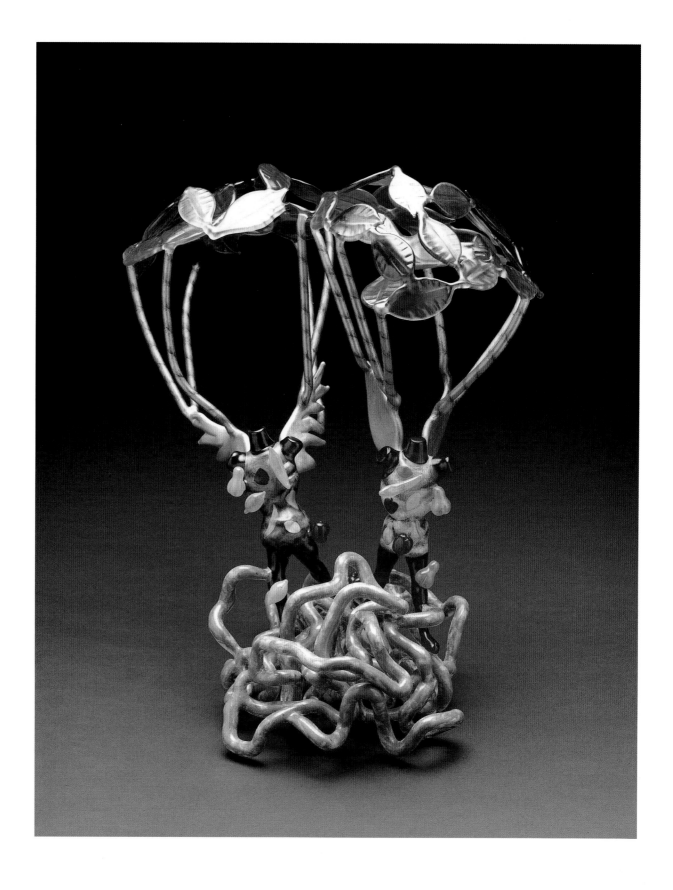

DAVID SCHWARZ

For three years in college I studied to be an engineer. I still have a passion for structures, and my main intent is to make a convincing illusion, a convincing universe that is an extension of my thoughts. I want your body and your eyes to work together in sensing that there is a deeper space in one of my objects than is actually there. I want people to get close to these pieces, fall inside of them visually, and move with them, even have a visceral sensation that follows from the visual response.

The lenses, or facets, on the pieces take my two-dimensional drawings and transform them into three-dimensional images, and, at the same time, bend and distort them. As you walk around a piece, the facets make the drawings seem to move. My work is trompe l'oeil; I'm trying to fool the eye. The challenge comes in trying to create a more perfect illusion.

facing page:

Z.A.O.F. 10-5-90
1990
Blown, etched, faceted
11½" × 16" × 16"

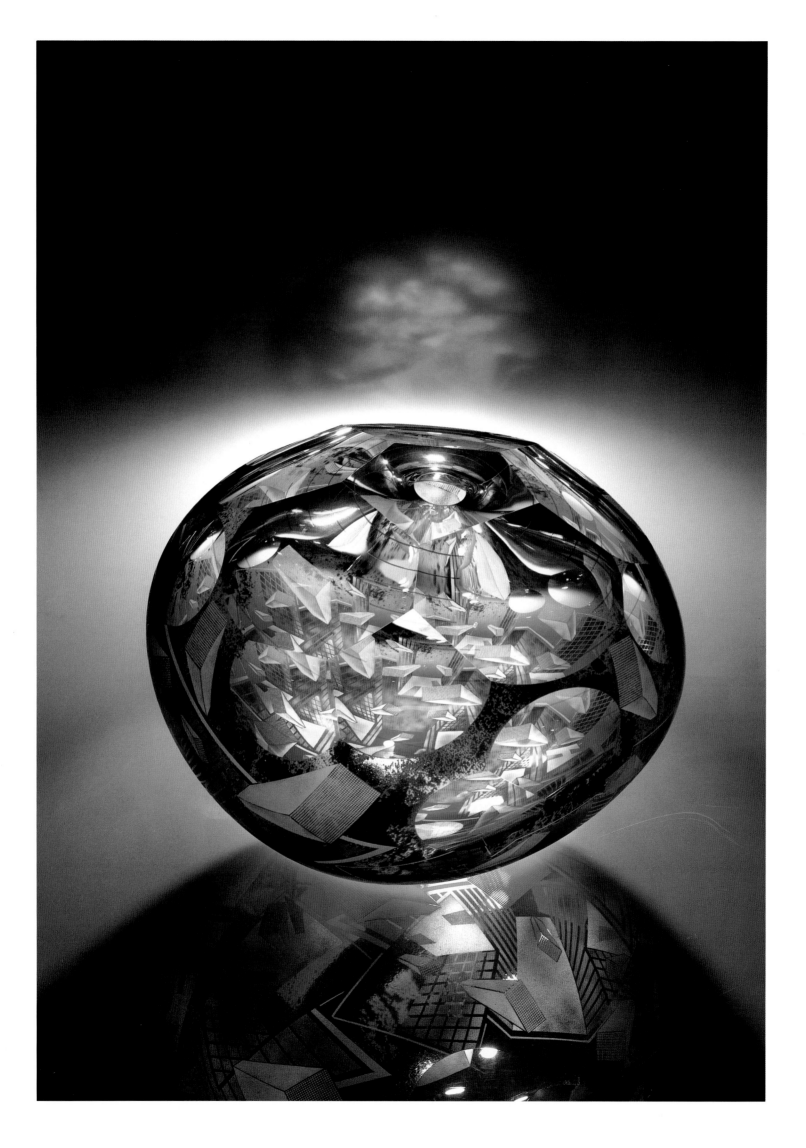

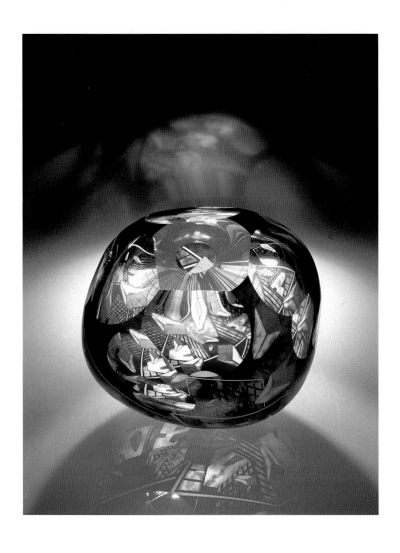

above:

Z.A.O.F. 4-11-90

1990

Blown, etched, faceted

13″ × 16″ × 16″

right:

Z.A.O.F. 10-23-90

1990

Blown, etched, faceted

10¾″ × 17″ × 13″

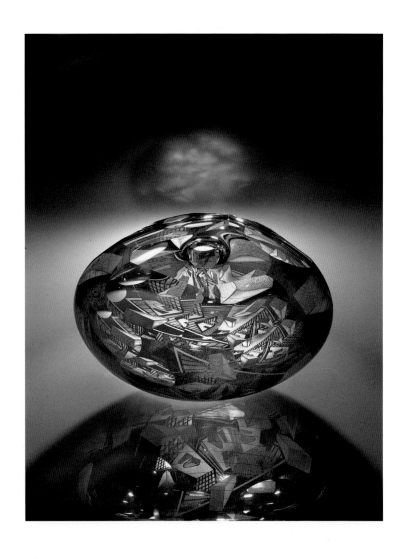

CATHERINE THOMPSON

I started painting on vessels the first summer I was at Pilchuck. Something wonderful that I didn't anticipate was that the vessel presented a whole other way of thinking about form. The vessel form is a metaphor for the world and seems to fit my use of myth and storytelling. Also, because of the transparency of the vessel, the images on the one side play off the images on the other. This was a new and fun way to draw, because a vessel is continuous and there seems to be no edges.

Making the composition is the most difficult and the most exciting, and then executing it is the work. Many people don't understand that my work uses a fired process that is done in layers. It isn't something that I just sit down and complete in one step. It has to be separated. People always wonder how and why the vessels are painted on the inside. A lot of people think it is impossibly difficult, but it isn't really. I like the optics of seeing the paint through the glass. You're not seeing the surface of the paint, so it integrates the drawing into the glass in a nice way. In addition, painting the glass offers infinite possibilities for subtlety in color and form, and enables me to make very detailed images.

Most of the time there is a general, deep pleasure I get from working. I feel so lucky to be doing work I love. Sometimes it is mundane and difficult to plow on, but at other times there is just the joy.

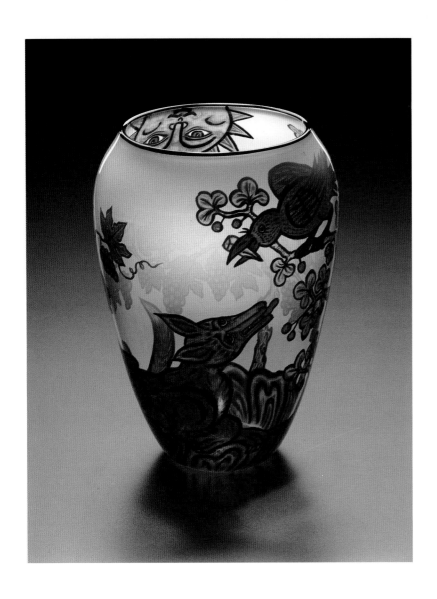

left:

THE FOX AND THE CROW

1988

Fired enamel on glass

17″ × 12″ × 12″

below:

BUDDHA SAYS GOODBYE TO THE ANIMALS

1988

Fired enamel on glass

12″ × 19″ × 19″

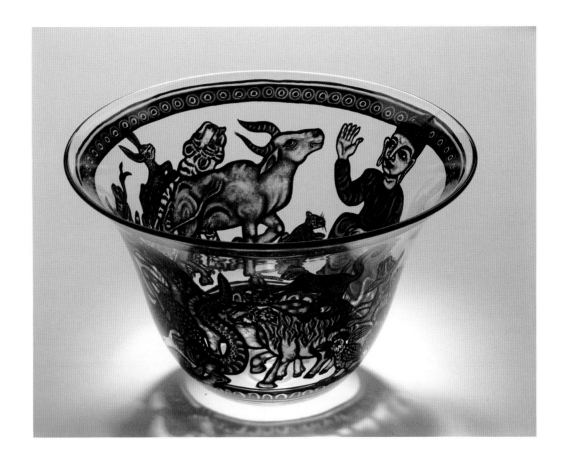

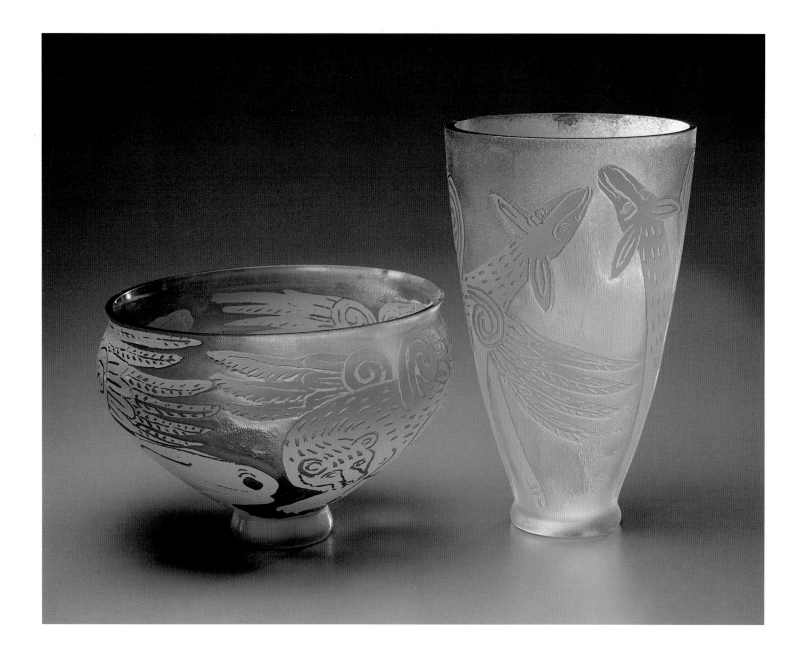

above:

WINGED ANIMALS [LEFT]

1990

Acid cut glass

9″ × 14″ × 14″

WINGED DEER [RIGHT]

1990

Acid cut glass

15″ × 9½″ × 9½″

MARY VAN CLINE

If I could say what single idea most influences my work, it would be the concept of time. Trying to define time is like being separated from something by a glass wall. At first glance, what is there appears easy to grasp. The closer you get, the more you realize that you will never be able to possess it. The best definition of time I ever heard is that it is one damn thing after another.

I am interested in the emotional and psychological effect of time and intrigued with our struggle to accept our length of time on earth. For several years I have utilized a technique of photosensitizing glass. I use photographs in my work for their power to evoke memories and for the timeless quality they can convey.

facing page:
CHAIR
1989
Reverse painting on glass,
photosensitive glass, hourglass
40″ × 36″ × 28″

above:

INSTALLATION AT CHICAGO
1988
Neon, wood, sandblasted plate glass
12′ × 10′ × 8′

facing page:

THE BALANCE OF TIME
1989
Photo sensitive glass,
reverse painting on
glass, crystal ball
40″ × 22″ × 15″

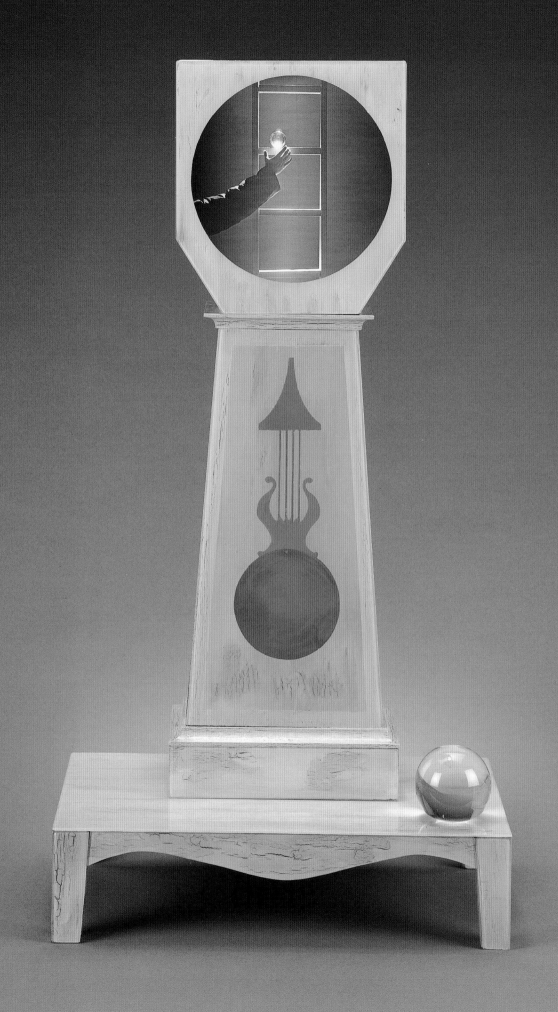

DICK WEISS

My three-dimensional portraits have been my main focus for the last several years. I have done many more self-portraits than I have done portraits of other people because I try too hard to please other people and the results almost turn into mall art. That constricts me. With my own image, I don't care if I look ugly. I'm not worried, so I am freer. In addition, when others sit for me, it takes a long time, and I can tell that they are bored or tired and want to leave. I can look at my own face all day, or I can come back to it. I don't complain, and I'm certainly cheap. There is also a certain amount of self-discovery. So there you go.

There is always the struggle between making art that other people can understand and still being true to my desire to experiment and to move on. I have gone through some major stylistic changes. From an intellectual standpoint, if I were going to look for fame in the field of glass, I would have stayed with one product, because people are not encouraged to buy your work when you jump around. You leave yourself open to a charge of not being serious, or not knowing what you want to do. But my gut has always told me when to change. After I'm dead, it won't matter if people take my stuff to the city dump or put it in a museum. I'm gone. So I'm going to have some fun while I'm here and try to please myself.

These vessels may be ignored, and a few of my friends may snicker at my doing all these self-portraits, but I enjoy them. At various times I think, "Pretty good. This one looks pretty cool. I like that one." Right now that is enough for me.

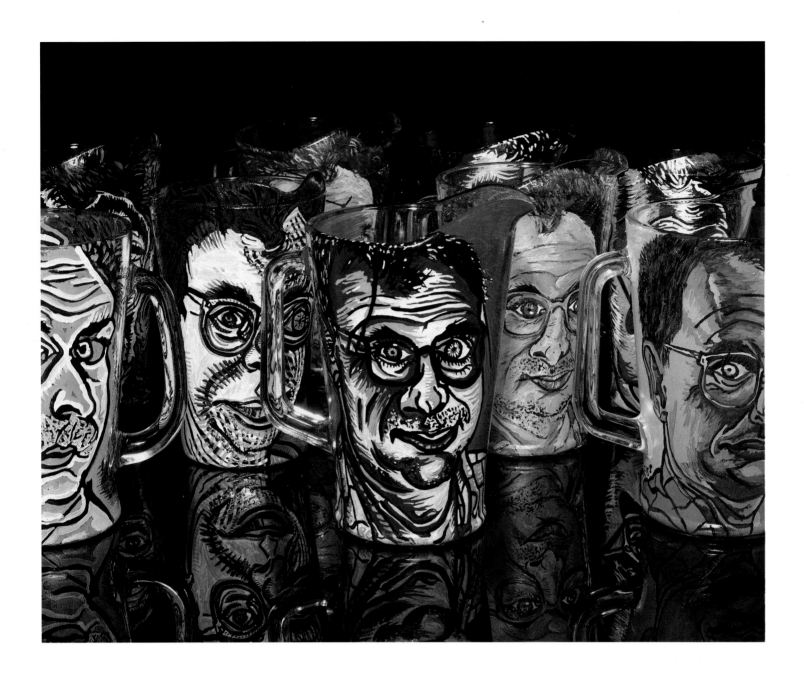

above:

PAINTED BEER PITCHERS

1988–1990

Fired glass enamels on glass

9" high

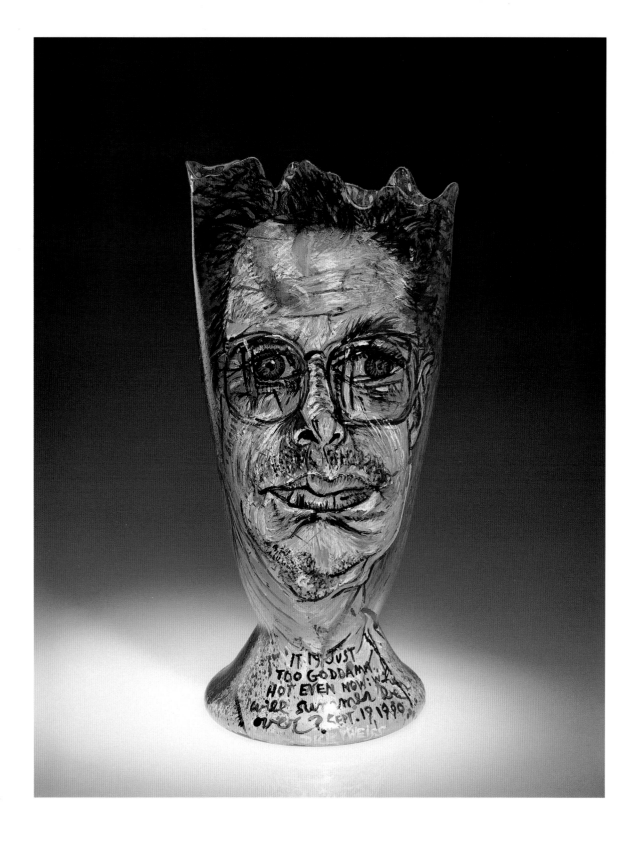

above:

SELF-PORTRAIT: IT IS JUST TOO HOT

1990

Fired enamel paint on blown glass

22" high

below:

SELF-PORTRAIT: HOMAGE TO W. M.

1990

Fired glass enamels on blown glass

15" high

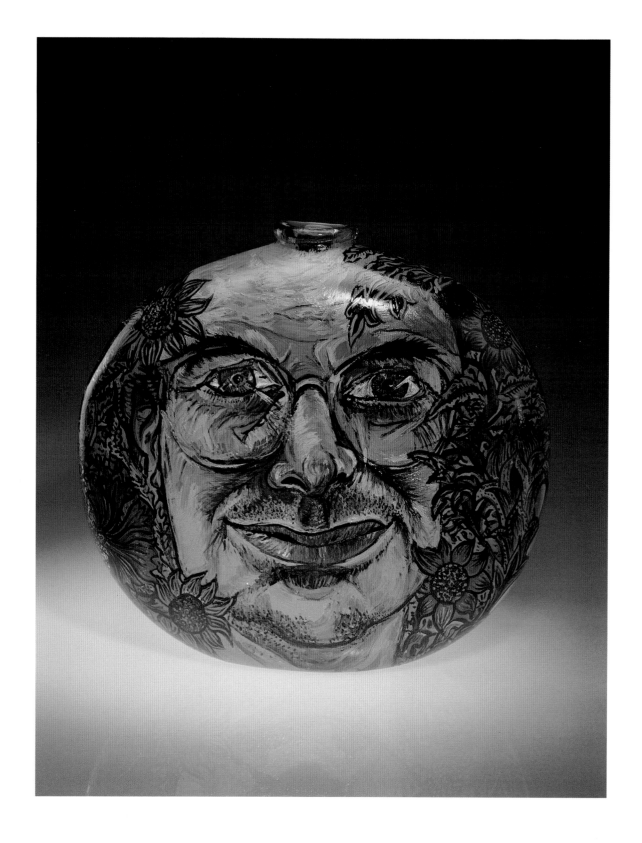

CREDITS

The artists and the following collectors, galleries, and museums have generously permitted the reproduction of the works of art illustrated in this book.

Sonja Blomdahl:
Cherry/Violet Bowl
Collection of Michael and Jeanie Coates,
Portland, Oregon
Citrus/Blue Pink Bowl
Collection of Mitsuyoshi Kusunoki, Mishima
City, Japan
Lavender/Egyptian Gold Bowl
Courtesy of the artist

Ruth Brockmann:
Tree of Life I
Courtesy of William Traver Gallery, Seattle,
Washington
Moon Deer Renewal
Courtesy of Works Gallery, Philadelphia,
Pennsylvania
Breath of Life
Courtesy of Maveety Gallery, Portland, Oregon

Robert Carlson:
What Tireseas Saw
Collection of David and Nancy Wolf,
Cincinnati, Ohio
Tiamat's Labours
Courtesy of Betsy Rosenfield Gallery,
Chicago, Illinois
Pan
Collection of Daniel Lipkie and Roberta
Goodrow, Bellevue, Washington

Dale Chihuly:
All pieces courtesy of the artist

KéKé Cribbs:
Simplicimus
Collection of Fred and Patty Turner,
Deerfield, Illinois
Caballero
Private collection
Paloma
Private collection

Fritz Dreisbach:
*Golden Mongo Compote with Multi-hue Filigree
and Cast Foot*
Collection of Judy North, San Geronimo,
California
*Ruby "Wet Foot" Mongo with Kissing Snakes and
Lily Pad Optics*
Courtesy of the artist
Champagne or Cognac Reversible Goblets
Courtesy of the artist

Stephen Dale Edwards:
Folded Dancer
Collection of John C. Williams/Steve Jensen,
Seattle, Washington
Vulnerable Traveler
Collection of Ray Frost Fleming/Robert L. Kidd,
Birmingham, Michigan
Hostage
Courtesy of the artist

Ann Gardner:
Untitled (Silver)
Courtesy of the artist and William Traver
Gallery, Seattle, Washington
Untitled (Green)
Collection of Saks Fifth Avenue, New York,
New York
Wings and Wood
Collection of Roberta Sherman, Seattle,
Washington

David Huchthausen:
Thistle
Collection of Judy and Bruce Bendoff, Deerfield,
Illinois
Recon
Courtesy of Habatat Galleries, Boca Raton,
Florida
Leitungs Scherbe 86C
Collection of High Museum of Art, Atlanta,
Georgia; purchased

Joey Kirkpatrick / Flora Mace:
All pieces courtesy of the artists

Richard LaLonde:
Remember There Are Stars in the Sky
Collection of Arlene and Harold Schnitzer,
Portland, Oregon
Cornucopia
Collection of Mr. and Mrs. David Stearman,
Bethesda, Maryland
Bol'ero with Red and Lime Checkered Corners
Courtesy of the artist

Walter Lieberman:
Tired of War 2
Collection of John and Joyce Price, Mercer
Island, Washington
Pandora's Box
Collection of Ann H. and John H. Hauberg,
Seattle, Washington
Venus of Indifference
Collection of Mr. and Mrs. Robert T. Ohashi,
Seattle, Washington

Dante Marioni:
Whopper Vase Form
Collection of Pacific First Centre Building,
Seattle, Washington
Assorted Goblets
Courtesy of the artist
Goosebeak Pitchers
Courtesy of the artist

Paul Marioni:
All pieces courtesy of the artist

Richard Marquis:
Wizards
Private collection
Grey Rock (Latticinio Bottle, Celadon Vase)
Private collection
Bell Jar #14
Collection of Johanna Nitzke, Freeland,
Washington

Nancy Mee:
Body Study
Courtesy of the artist and Linda Farris Gallery, Seattle, Washington
Seven Beauties
Courtesy of the artist and Linda Farris Gallery, Seattle, Washington
Encased in Their Beliefs
Collection of SAFECO Insurance Companies, Seattle, Washington

Benjamin Moore:
Hornet Lamp
Unknown
Three Floor Lamps
Courtesy of the artist
Palla Series
Unknown

William Morris:
Artifact Still Life
Collection of Simona and Jerome Chazen, Upper Nyack, New York
Petroglyph Vessel
Courtesy of the artist
Burial Urn
Collection of Duff and Dorothy Kennedy, Seattle, Washington

Charles Parriott:
Meesha
Private Collection
Hungry Bear
Courtesy of the artist
Flowered Soldier
Courtesy of the artist

Danny Perkins:
Yellow Rib
Collection of Sandy Solmon, Reading, Pennsylvania
Red with Green
Collection of Patrick Gordon and Christine Lamson, Seattle, Washington
Green with Yellow Dot
Collection of Linda and Alan C. Alhadeff, Seattle, Washington

Susan Plum:
All pieces courtesy of the artist

Amy Roberts:
Man with Pox
Courtesy of the artist
Spiral Head
Private collection
Beginnings
Collection of Lance LaCerte

Richard Royal:
Shelter Series, "Interlock #137"
Collection of Angelo Pulos, Vancouver, British Columbia
Diamond Cut Series—Untitled #140
Collection of Tosei Corporation, Honolulu, Hawaii
Diamond Cut Series—Untitled
Courtesy of the artist

Bryan Rubino:
All pieces courtesy of Regalo Vetro, Seattle, Washington

Ginny Ruffner:
Beauty as Ideas
Courtesy of the artist
La Donna Mobili
Private collection
Stella at the Louvre
Private collection

David Schwarz:
Z.A.O.F. 4-11-90
Collection of Hansen Machine Corporation, Kent, Washington
Z.A.O.F. 10-23-90
Courtesy of the artist
Z.A.O.F. 10-5-90
Courtesy of the artist

Catherine Thompson:
The Fox and the Crow
Private collection
Winged Animals
Courtesy of the artist
Buddha Says Goodbye to the Animals
Courtesy of the artist and Gump's Gallery, San Francisco, California

Mary Van Cline:
Installation at Chicago
Private collection
Chair
Courtesy of the artist
The Balance of Time
Private collection

Dick Weiss:
Self-Portrait: Homage to W.M.
Courtesy of the artist and William Traver Gallery, Seattle, Washington
Self-Portrait: It is Just Too Hot
Courtesy of the artist and William Traver Gallery, Seattle, Washington
Painted Beer Pitchers
Courtesy of the artist

ARTISTS' GALLERIES OR REPRESENTATIVES

For more information about the artists presented in this book, contact their galleries or representatives; a partial list follows.

Sonja Blomdahl
Gump's Gallery, San Francisco, California
Joanne Rapp Gallery, Scottsdale, Arizona
Maveety Gallery, Portland, Oregon
Maveety Gallery at Salishan,
Gleneden Beach, Oregon
William Traver Gallery, Seattle, Washington

Ruth Brockmann
Kurland/Summers Gallery, Los Angeles, California
Maveety Gallery, Portland, Oregon
The Glass Gallery, Bethesda, Maryland
The Works Gallery, Philadelphia, Pennsylvania
William Traver Gallery, Seattle, Washington

Robert Carlson
Betsy Rosenfield Gallery, Chicago, Illinois
Foster/White Gallery, Seattle, Washington
Heller Gallery, New York, New York
The Glass Gallery, Bethesda, Maryland

Dale Chihuly
Charles Cowles Gallery, New York, New York
Foster/White Gallery, Seattle, Washington
Gerald Peters Gallery, Santa Fe, New Mexico
John Berggruen Gallery, San Francisco, California
Pence Gallery, Los Angeles, California

KéKé Cribbs
Anne Reed Gallery, Ketchum, Idaho
Habatat, Boca Raton, Florida
Habatat, Farmington Hills, Maryland
Heller Gallery, New York, New York
Kurland/Summers Gallery, Los Angeles, California

Fritz Dreisbach
Maurine Littleton Gallery, Washington, DC
William Traver Gallery, Seattle, Washington

Stephen Dale Edwards
Foster/White Gallery, Seattle, Washington
Judy Youens Gallery, Houston, Texas
Robert Kidd Gallery, Birmingham, Michigan
The Glass Gallery, Bethesda, Maryland
The Works Gallery, Philadelphia, Pennsylvania

Ann Gardner
Allrich Gallery, San Francisco, California
Jamison Thomas Gallery, Portland, Oregon
Linda Farris, Seattle, Washington

David Huchthausen
Habatat, Detroit, Michigan
Heller Gallery, New York, New York
William Traver Gallery, Seattle, Washington

Joey Kirkpatrick/Flora Mace
Not available

Richard LaLonde
Gallery Mack, Seattle, Washington
Marx Gallery, Chicago, Illinois
The Glass Gallery, Bethesda, Maryland

Walter Lieberman
The Glass Gallery, Bethesda, Maryland
William Traver Gallery, Seattle, Washington

Dante Marioni
William Traver Gallery, Seattle, Washington

Paul Marioni
Brendan Walter, Santa Monica, California
Sanske Galerie, Zurich, Switzerland
William Traver Gallery, Seattle, Washington

Richard Marquis
Betsy Rosenfield Gallery, Chicago, Illinois
Kurland/Summers Gallery, Los Angeles, California
Sandra Ainsky Gallery, Toronto, Ontario

Nancy Mee
Allrich Gallery, San Francisco, California
Linda Farris Gallery, Seattle, Washington

Benjamin Moore
Connell Gallery, Atlanta, Georgia
Kurland/Summers Gallery, Los Angeles, California
William Traver Gallery, Seattle, Washington

William Morris
Betsy Rosenfield Gallery, Chicago, Illinois
Brendan Walter Gallery, Santa Monica, California
Foster/White Gallery, Seattle, Washington
Maurine Littleton Gallery, Washington, DC

Charles Parriott
Butters Gallery, Portland, Oregon
Gump's Gallery, San Francisco, California
The Glass Gallery, Bethesda, Maryland
William Traver Gallery, Seattle, Washington

Danny Perkins
Heller Gallery, New York, New York
Judy Youens Gallery, Houston, Texas
William Traver Gallery, Seattle, Washington

Susan Plum
Not available

Amy Roberts
Duplantier Gallery, New Orleans, Louisiana
Garland Gallery, Santa Fe, New Mexico
Joan Robey Gallery, Denver, Colorado
Wita Gardiner Art Consultants,
La Mesa, California

Richard Royal
Christy Taylor, Boca Raton, Florida
Fine Art Association at the Loft, Honolulu, Hawaii
Foster/White Gallery, Seattle, Washington
Gump's Gallery, San Francisco, California
The Glass Gallery, Bethesda, Maryland
Vesperman Glass Gallery, Atlanta, Georgia

Bryan Rubino
RegaloVetro, Seattle, Washington

Ginny Ruffner
Heller Gallery, New York, New York
Holsten Gallery, New York, New York
Linda Farris Gallery, Seattle, Washington
William Traver Gallery, Seattle, Washington
Maurine Littleton Gallery, Washington, DC
Sanske, Zurich, Switzerland

David Schwarz
Foster/White Gallery, Seattle, Washington
Holsten Galleries, Palm Beach, Florida
Judy Youens Gallery, Houston, Texas

Catherine Thompson
Betsy Rosenfield Gallery, Chicago, Illinois
Gump's Gallery, San Francisco, California
William Traver Gallery, Seattle, Washington

Mary Van Cline
Habatat Gallery, Boca Raton, Florida
Joan Robey Gallery, Denver, Colorado
Judy Youens Gallery, Houston, Texas
Maurine Littleton Gallery, Washington, DC
William Traver Gallery, Seattle, Washington

Dick Weiss
William Traver Gallery, Seattle, Washington